TRAGIC CITY

ANHINGA PRESS

Though the nostalgic path that is memory often catalyzes a poets' lyric search for both language and measured rhythms which define their immediate presence in the world, longing alone will not guarantee an end to the oblivion. One must attempt, as Clemonce Heard does here in *Tragic City*, to confront the intractable reality that smashes illusions of any civilized code; one must "[groove] with the upright history / of a people." Heard provides many occasions for readers to meditate on the Tulsa Race Massacre — not as an exercise in "wokeness," but as a means of launching grace. These poems model benevolence and presence, and I for one will return again and again to their virtues and music.

— Major Jackson
Judge, 2020 Anhinga-Robert Dana Prize for Poetry

Clemonce Heard's penetrative and muscular debut probes the blatant brutality perpetrated by white men from the towering perch of their self-imposed birthright — with unerring focus on the "tragic city" of Tulsa, Oklahoma, where, in 1921, that mercenary privilege resulted in the utter decimation of the flourishing black community of Greenwood, and the deaths of hundreds of its citizens. Since the massacre is still unknown to so many, Heard urgently transports the reader into the moments of the tragedy, reviving the people and places that gave Greenwood its pulse — then moves into the disquieting present day, where the circumstances that led to that titanic loss still exist, and still resound.

— Patricia Smith, author of *Incendiary Art*

TRAGIC CITY

CLEMONCE HEARD

2020 ANHINGA-ROBERT DANA PRIZE FOR POETRY
Selected by Major Jackson

ANHINGA PRESS
TALLAHASSEE, FLORIDA 2021

Cover photograph: "Flowers in North Tulsa" by Nicole Donis

Author photograph: Heyd Fontenot (heydfontenot.com)

Illustration on page xiv: "A Broken View of Tulsa, Oklahoma" by Carley
Schmidt, hand-cut screen print on archival inkjet point (carleyschmidtart.com)

Design and Production: Carol Lynne Knight

Type Styles:
Text set in Corundum Text Roman designed by Joshua Darden. Titles set in
Big Noodle Titling designed by James Arboghast.

Library of Congress Cataloging-in-Publication Data
Tragic City by Clemonce Heard — First Edition
ISBN — 978-1-934695-71-5
Library of Congress Cataloging Card Number — 2021936319

Anhinga Press Inc. is a nonprofit corporation dedicated wholly to the
publication and appreciation of fine poetry and other literary genres.

For personal orders, catalogs, and information, write to:

Anhinga Press
P.O. Box 3665 • Tallahassee, Florida 32315
Website: www.anhingapress.org • Email: info@anhinga.org

Published in the United States by Anhinga Press
Tallahassee, Florida • First Edition, 2021

For Greenwood

CONTENTS

Acknowledgments x

*Preface: Authors of Devastation, A Letter to Tulsa
on the 100th Anniversary of the Massacre* *xiii*

Illustration, "A Broken View of Tulsa, Oklahoma" *xiv*

Commentary 1

Genius Annotations Provided: "You Dropped a Bomb on Me" 4

Race to the Riot 9

Teaching Artist Quad 10

Amazing Grace 13

The Civil Rights Museum Desecrates the Memory of Dr. King 14

Our Hands are Bowls of Dust 16

Headed North on the Midland Valley Railroad Tracks 17

Move-in Day @ The Refinery 18

Neighbors 19

Nitroglycerin, 21

Recommendation 24

Malt O Meal, Since 1919 26

When Tulsa Nearly Killed Queen 27

A Baby Wedged Between Two Buildings 30

Maintenance @ The Refinery 31

My Fellow Gentrifiers 32

Worlds Largest Praying Hands 33

Rawhide 34

Escape Artist 35

Reflections on Reflections of El Lissitzky 36

Murmuration @ The Refinery 39

Sand Springs 40

The Gospel of John the Baptist Stradford 43

To: Aboard, From: Abroad 44

The Jazz Hall of Fame 47

Southwest Swing 49

Suga Water 50

Oklahoma Needs an NFL Team 52

Battle Ground @ The Refinery 53

Against the Horizon 54

Copperhead that Wanted to be Spittle Bug that Wanted to be
 Scorpion Fly that Wanted to be Archerfish that Wanted to be
 Walrus that Wanted to be Camel that Wanted to be Cobra 55

Panhandlers 56

The Lightbulb Room 59

Compartmentalizing @ The Refinery 60

Tulsa Searches for Sass Graves 61

St. Louis I.M. & S. Ry. Co. V. Freeland 63

Pioneer Woman, Ponca City 64

The Creek Council Oak Tree 65

Cinder/ella 67

The Soi Disant 68

$465,000,000 Gathering Place 70

$36,000,000 Restoration of the Tulsa Club Hotel 71

First Snow @ The Refinery 72

Domestic Day Off: Hangover 73

Dapper 75

Tulsa Star 77

Pesticide is to Chigger, as Turpentine is to _____ 78

Incen/diary 79

Washington Parish Free Fair 80

Hot Girl Summer 82

My White Wooer Whistles "Whistle While You Twurk" 84

The Steps to Nowhere 85

The Interpreter 87

New Streets @ The Refinery 89

Dirty Butter Creek 90

Paris Soul Food 92

Ninety-nine 93

On Your Final Night in T-Town 99

A Noble Parting Gift: Rose Rock 100

Notes 104

Bibliography 106

About the Author 108

ACKNOWLEDGMENTS

This book could not have been written without my loved ones, fellow artists, and the institutions that supported me.

To save the best for first, I am grateful for my family, most especially Moms, Pops, Anie, Nephew, Mawmaw, Uncle Carl and Aunt Vickie. Thank you for shaping how I view inheritance and the ways we're able to give back to our communities.

Shout out to the friends who got me to and through the book and beyond, most especially, to Irene B., Rashad B., Ryan C., Kevin R., and Anh V., who first taught me the possibilities of friendship. To my Brainy Acts Poetry Society family, most especially, Dante B., Jamie E., Elizabeth K., Matthew M., Janasia S., and Daryl S. for inspiring me inside and outside the work. To Castel S., thank you for your support and for urging me to pursue a degree in creative writing. To Eldon B. for your friendship and your generosity that allowed me to create the majority of this work. To Christina L., Mahmoud A.T., Chris W., and Janina G. for seeing me through the beautiful and difficult times of grad school. To Christine N., Kelila K., and Shanley W.-R., my workshop squad plus some. To Susan A., Christina B., and Eyakem G. for your generosity and introductions to The City. To Anna B. and Yielbonzie J. for prioritizing friendship, words, and food. To Heyd F., Simon H., and Laurie T. for prioritizing the need for nice moments. To Gabriel L., thank you for the friendship and space you lent till I got on my feet. To Ajibola T. — your presence and passion for life, for poetry invigorates me. To Morgan M.-J. (Fay), thank you for the room you continue to make for me, and the healing you teach through example.

Shout out to my instructors and others who invested in me during the book's inception. To Julie Kane, my poet mama, I would ask how many doors you've opened, but you're not counting. To Lisa Lewis, my friend and guide from the get go. Thank you for looking close enough to see what was buried under all those sonics. To

Janine Joseph, thank you for standing up for me and my work. To Trey Moody, for your chill and shared delight in the tiny details. To Sarah Beth Childers, for showing me the poetry in creative nonfiction. To Lisa Hollenbach, for your thoughtful and expansive introduction to documentary poetics. To Lindsey Clare Smith, for your teachings, your friendship, and your resounding "whoops!" I've made leftovers with. To Jeanetta Calhoun Mish for extending actionable support. To Naomi Shihab Nye, what better time to be in San Antonio and recieve your friendship, advocation, and hospitality. Amaud Jamaul Johnson, for the subtle ways you teach how to show up with integrity, and to Amy Quan Barry, for managing a community of support in both work and wellness. Gratitude.

Shout out to my editor, Carol Lynne Knight. I am grateful for your thoughtfulness, sincerity, and openness, even when you don't understand "the slang." Ha! This is what putting a book together is supposed to feel like. Thank you. To Nicole Donis for the cover photo and framed version that remains mounted above my desk. To Carley Schmidt, thank you for collaborating with me without the security of knowing if our experiment would meet the public eye. To Anhinga Press for seeing wonder in this work, for giving me extra time to unpack that wonder, and for the many wings that made these pages possible. Thank you to Major Jackson for choosing "Tragic City" and helping it into the world.

Shout out to the writers whose work stayed in rotation during the making of this collection, a few of whom are also friends: Tiana Clark, Eduardo C. Corral, Natalie Diaz, Ross Gay, Terrance Hayes, Major Jackson, Ilya Kaminsky, Kiese Laymon, Li-Young Lee, Robin Coste Lewis, Diana Khoi Nguyen, Roger Reeves, Patricia Smith, and Natasha Trethewey.

Thank you to the following institutions that supported me: Northwestern State University, The Louisiana Book Festival, Electic

Truth, Festival of Words, Oklahoma State University, The Red Earth Creative Writing MFA at Oklahoma City University, The Ralph Ellison Foundation, Furious Flower Poetry Center at James Madison University, The Watering Hole, The Tulsa Artist Fellowship, Wiley College, Langston University, The Conversation Group, The Center for Poets & Writers-OSU-Tulsa, University of Wisconsin's Institute for Creative Writing, Sala Diaz, Tupelo Press, and Anhinga Press.

Lastly, thank you to the following publications that selected my work, some in slightly different versions:

AGNI: "The Interpreter" and "Malt O' Meal, Since 1919"

Art Focus Oklahoma: "$36,000,000 Restoration of the Tulsa Club Hotel"

Cimarron Review: "Amazing Grace," "Copperhead That Wanted to be Spittle Bug That Wanted to be Scorpion Fly That Wanted to be Archerfish That Wanted to be Walrus That Wanted to be Camel That Wanted to be Cobra," and "The Soi Disant"

Green Mountain Review: "When Tulsa Nearly Killed Queen"

The Missouri Review: "Genius Annotations Provided: 'You Dropped a Bomb on Me'" and "Teaching Artist Quad"

Nimrod: "Washington Parish Free Fair"

Obsidian: "Commentary"

Opossum: "Southwest Swing" and "To: Aboard, From: Abroad"

Rattle: "Ninety-nine"

Ruminate: "Our Hands are Bowls of Dust"

Tupelo Press: "A Noble Parting Gift: Rose Rock"

World Literature Today: "Incen/diary" and "Against the Horizon"

AUTHORS OF DEVASTATION

LETTER TO TULSA
ON THE 100TH ANNIVERSARY OF THE MASSACRE

Like many of my earliest drafts of anything, when I first started writing to you, I was imitating what I thought a preface was supposed to sound like. As a matter of fact, those drafts weren't even to you, but at you. They denounced your downtown all decked out in Art Deco. They laid into your half-sized replica of the World Trade Center. I walked all over you — strolled through your tunnel that once smuggled your first king back and forth between his Philtower office and Philcade penthouse apartment. I said things behind your backstreets. I said things to the facades of what remains of Greenwood that had you heard, you would've hoped I'd never repeat. Like some of the other newcomers who also wolfed down your history, at one point I couldn't tell if what I created was out of respect or for personal gain. I said yes to the same comforts I critiqued. I wrote with the intention to take the focus away from the fact that I was an interloper.

I tried to clear my name.

I arrived as one of many artists, though you had no shortage of your own, on a fellowship seldom offered to your own. Some of us were given plush lofts in one of your warehouses converted into studios, restaurants, wannabe bodegas, and a bookstore. Our floor was called "The Refinery." Here, some of us were censured, yelled at, lied to, surveilled. Some pushed back, yelled back, fell back, and only showed their faces for monthly meetings to collect their stipends. Some of us came from, and some of us went onto other dysfunctional institutions. Some of us thought we were awarded unrestricted space and time to create, but instead were taught the backhandedness of benevolence. At night, from my bed pushed against the exposed brick, I'd walk across the concrete

floor to the awning window and look out my arts district loft to see your downtown. Only, I saw a cutout background of a theater set — plywood looming like a false tyrant. I dreamt I shoved you down. I dreamt your buildings dominoed all the way to the Arkansas River where it was rumored Black massacre victims were thrown. I dreamt that all the mass graves were found, memorialized, and given a proper burial.

I wanted to know their names.

My first few months were spent with a friend I met at your Jazz Hall of Fame, transformed from your old train depot. An elder, he was born and raised in Greenwood rechristened North Tulsa. He attended Booker T. Washington High School, one of the only buildings your white mobs didn't set aflame. He disagrees with Washington: "Why would we want to be called Black Wall Street?" he'd ask, "It's Greenwood." In his constant bickering, he made me laugh, and unintentionally taught me how to hate on you, but refused to let me go all the way in. You were the sibling only he and other locals could badmouth. What Maria Tumarkin named a *traumascape*. My heartbreak wasn't just from the fellowship's staff, but finding out that along the train tracks less than one hundred yards away from my loft, the most violent battle of the massacre took place. It was understanding that the sidewalk, street, and parking lot I looked down upon was sacred ground, partly because it was once Greenwood, partly because of the bloodshed, and partly because it had also once belonged to the Muscogee Nation. If I'd known what had happened before moving into the warehouse, I would've chosen to live at one of the fellowship's other locations. The more I read, witnessed, or learned from my friend, the more disgusted I became. When he wasn't bickering, he was taking me in, calling me "brother," and driving us away from the misery associated with the arts district. I plotted my escape from your "promised land."

I called you out your name.

You should know, there are others like you — Magic cities — about 20 others. Most of them, like you, mushroomed in population and infrastructure overnight. Like you, at least one of them, Bogalusa, Louisiana, was once a cesspool for the KKK. Yusef Komunyakaa's '92 collection *Magic City* brings us to the Bogalusa of his youth. The title is tongue-in-cheek unlike you. Years ago, I read a story about Cynthia Lynch, who took a bus from your Detroit Avenue station to Bogalusa to join the Sons of Dixie Knights. She was said to be childlike, and had been recently diagnosed with bipolar disorder and schizophrenia. At one point in the initiation, Lynch came to her senses and screamed, "I want to go home! I've had enough of this! I want to quit! I want out now!" I won't say how, but you should know she was murdered. That like you, there was nothing magic about it. Magic is no longer magic once we understand how the trick is done — once the rabbit is found unresponsive in the top hat. There is a word for this woman slain for what she hoped to become by hopping a bus to go from one Magic City to another. That word is tragic.

I wanted to change your name.

My last few months were spent walking through your downtown, trying to imagine how it all went down — Dick Rowland bolting from the Drexel Building after Sarah Page's scream. The rickety jail where Rowland was first locked up, now a parking lot. I imagined a cockroach crawling across the wall of his cell. The setting sun burnishing its back, better than he or any other bootblack he knew could polish. I attended concerts at your Guthrie Green, Cain's Ballroom, Gathering Place. I met your current king. He was a charcoal suit in sneakers. He paid for my dinner. He paid for all my dinners. He told the server he could "lick it clean" when she asked to take his plate. I know we are similar, but not the same — you just

wanted to imitate what you thought was the makeup of an American city: I just wanted to imitate what I thought a preface to this collection was supposed to sound like. There are several historians and authors I am thankful for who can offer you a more exhaustive account. This is just what I was able to get down. May it allow for a more intuitive investigation and conversation surrounding what remains tragic about you. May you come to a true reconciliation, and by those actions, may you be named.

— Clemonce Heard
August 12, 2021

TRAGIC CITY

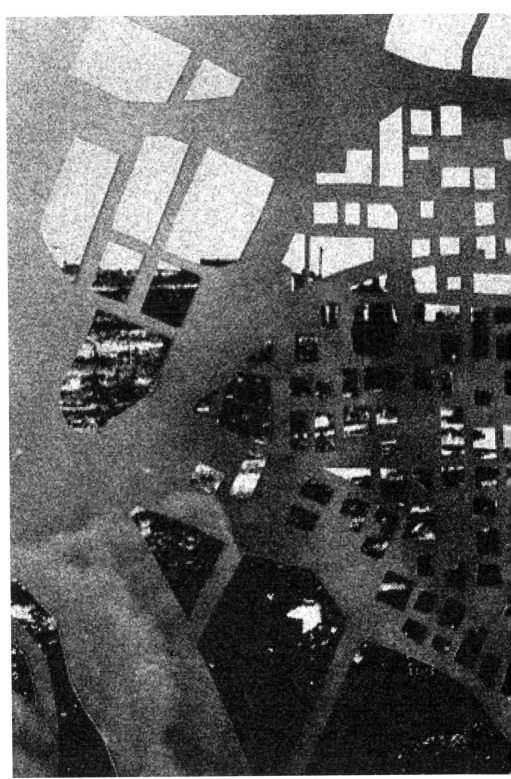

A Broken View of Tulsa, Oklahoma

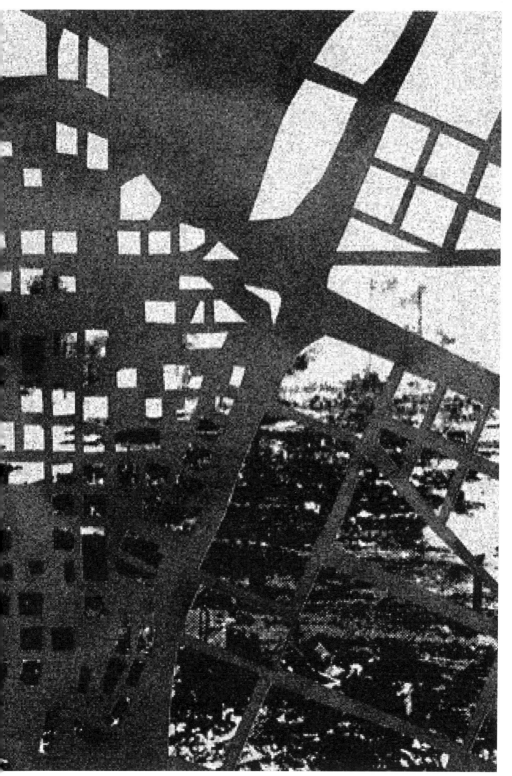

COMMENTARY

This distressed tee is an essential piece
for the Black male, with its wounds scattered

throughout the chest, ribs & sleeves. It has debuted
as a new take on post-racial chic; each tear

deliberately placed in locations where
the Black male's skin is most commonly pierced.

Here you'll see the selvaged hem: how it doesn't
flow like blood, ends fringed like finger-length

dreads. Undressed or under duress the distressed
tee is a must-have for any target. Its ragged

look has made it the most sought after garment
of last summer & this fall, though it's a rather old addition

to the harassed trend of blackness. Here you'll see
it juxtaposed with frightened badges & a frayed

pair of black skinny jeans. However, on a nice Friday
evening, in or out the hood, it can also be coupled

with cuffed, white chinos or brutally battered
deputy blue denim to contrast the carmine splatters

you're sure to find on nearby windows, passenger
seats & of course concrete. I'd sport the depleted

piece with pleads & pleated cotton khakis,
& recommend it to the tinted & the offended.

Light as a fleeing spirit & highly perforated
to allow enough oxygen to enter the struck down

& strangulated; to convey mumbled gasps cops
seem unable to comprehend. This shirt leaks

personality & is relaxed & long enough
that the Black male cannot raise his kids, but can

raise both hands in the air when approached
with arms & not have to deal with the anxiety

of being charged with the criminal offense of marching
up & down a boulevard while revealing his undergarments.

Its extended tail is perfect for abrupt breakdowns,
along with "justice" upticks, as it allows others to see

there's no weapon to draw without drawls
unveiled. Personally, I love the versatility

of this piece, as it's an arresting accessory to the hoody;
how it peeks from beneath like a blown taillight.

Try pairing it with bomber jackets as the bottom hem
skims the zipper's flap with an elongated curve

like a shut lid. It makes sense for this hipster & holstered
fashion of shabby snazziness to be matched with any

misidentified Black male & the muggings he failed
to commit. Thus this frustratingly frazzled style,

purposefully mutilated, capable of complementing
any Air Jordan sneaker is now retroactively available

in many stores, stairwells and routine stops near me.

GENIUS ANNOTATIONS PROVIDED:
"YOU DROPPED A BOMB ON ME"

If this funk hit isn't reminiscent of the massacre
with its whistling of descent & combustible
drum rolls, then the trio's bedazzled camouflage
& 2-bit bombers gilding the video will surely make
witnesses feel like they've marched back in time.

<p style="text-align:center">⬦</p>

Since I told the woman whose hair is a waft
of smoke I have a *crush* on her, it's something
I've been trying to define: What it means to see
an interest one has or still desires from a distance
& what it means to subdue, oppress, gentrify.

<p style="text-align:center">⬦</p>

Sometimes I ask white folks working at gutted
warehouses turned bookstores, restaurants,
breweries where they stand. Most of them grin
assimilationist, others squint race doesn't exist,
rarely do they realize I'm referencing the land.

<p style="text-align:center">⬦</p>

The line "You lit the fuse, I stand accused"
may refer to Dick Rowland aka "Diamond Dick"
allegedly running from the elevator and its young
white operator like a swift burning wick, a manic
flame; like a man escaping a blame not his own.

4

On the way to get away, my crush & I made out
two white women taking pics of a brick shell
that was once a business. When she told me
I see this all the time on this side of the tracks
I wondered why some find ruination so captivating.

It hasn't been five months, but the structure
across from my apartment is nearly done. When I
told one of my friends it feels like I'm sleeping
outside, even on Saturdays, he replied *they must
be trying to get it up before the Lord descends.*

"You were the first explosion" may also refer
to a bomb, or a mob lighting a house on fire
& the "corrosion" that follows. Many Black
homes had gas lines. Many Black homes caught
fire just by sitting beside or behind one another.

The one time my crush who drives a carriage
& I danced wasn't a riot, rather an unsynchronized
bopping & spinning. We could see the pastime
stadium from where we clung. Its lit, green field
vast enough to house over ten thousand tenants.

A constructive way to reimagine an afterthought
is to name it *spontaneity* — something unplanned
that to the privileged sounds like a good idea.
Similar to *crush,* I'm digging this from the rubble,
along with, of course, the town favorite, *reconciliation.*

To be *turned on* is to be aroused, to be *turned on*
is to be activated, to be *turned on* is to be attacked.
Likewise, to be *turned out,* is to be whipped, to be
turned out is to be banished, & a *turn out* signifies
who showed up for fanfare & who for warfare.

When the woman whose skin tags resemble
bits of ash or charcoal told me she had reservations
about our relationship, I tromped to the tracks,
bindle sack in hand, ready to go. I waited for her
far off figure or a train to jump but neither showed.

Even if they don't claim one another we all know
envy & invasion arc cousins. To say the raids
had no relation to Black Tulsa's affluent community
is like saying oil cannot be set ablaze. Like saying
there were no families that shared the same grave.

The *Ah-Ah-Ah* in "I-I-I won't forget it" warbled
by a woman of mystery is meant to simulate
the pain of repeatedly burning oneself, the sight
of the leech-like blister when it swells & the scar
neither time nor suppression can efface.

I'm now wise enough to know sentiments conveyed
prematurely can trigger a type of pain. When I hear
post-racial country my instinct is to hiss or suck air
through my teeth. When I think of the warmth
I divulged, I shake my skull in disbelief of its stake.

Yet another Juneteenth dampened by sprinklers
of fireworks. A raucous ruckus of rockets launched
from the baseball field built where Blacks were
driven out. I'm not sure what's more traumatic:
the echoes of gunfire or the blood-tinted clouds.

The caesura between "bomb on me" & "baby" always
gets me: separator of action & actor, comma not a
come on, but an accent to the tender tension
of making your feelings known to the person
who's done you wrong, but also loved you right.

Sarah Page, the white elevator operator, is said
to have screamed after Rowland stepped on her toe
or after he tripped into her or after a quarrel.
The latter may point to the potential romantic affair
unanimously rejected by the shaft, carriage, & rope.

Though bridges are historically used to bring
together, like train tracks, they are also dividers.
I knew once I started north from my inamorata,
I'd become an outsider. I knew that once I hiked
under the overpass, there was no coming back.

On warm nights I can hear the tank cars shriek past
like a woman whose lost everything; the tankards
of ale pedaled down Archer Street & the prayers
of passersby. When I can't fall asleep I kneel at
my window. Wait for the plain-dressed mobs to arrive.

After the massacre, city ordinances prohibited
Blacks from rebuilding their homes. They spent
months in tents the color of bandages covering
too substantial of a wound. A wound still refusing
to heal. A wound nearly a century has failed to air out.

RACE TO THE RIOT

GEORGE MONROE (1916-2001)

every sunday we stole coal from the freight cars
 to throw at the white kids and they did the same
we didn't know what hate was we just wanted
 to emulate what we saw our folks do we threw
and threw and threw in the name of our landlords
 and they threw at us like the land was their lord
that had to be where i got my throwing arm
 where i learned to take a licking and keep going
i remember getting stoned in my right leg it left
 a mark darker than my eyes my skin or a bruise
it made me smirk but boy did it hurt the best
 thing was when our throws landed they turned
darker than the coldest of hearts and thanks
 to our sooty hands our teeth were our only white parts

TEACHING ARTIST QUAD

for the students, teachers, and staff of Drexel Academy

I. *Recess at the Osage Casino*

Just like Claremore, city I once believed
stood for clear more trees, they stripped the land
so the kids could see no skyline but the sign
droning in all its orange glory.

The clustered building blistering the mute
horizon resembling a castle from
the playground's parent-teacher assembly.
From the branches the kids climbed, sometimes

unable to get down. I have no clue
what the land between the school & gambling
looks like now, except a pond & pump jacks
drilled into the ground of my memory.

But I'm for certain the students I learned
remember me. That some of their hip hugs
now wrap my waist, mid-back, others even
tall enough to look me in the face.

II. *Field Notes in a Dry Spell*

When one ran out of nature, the only
sensible thing was to limn the playground:
jungle gym a cast net, the slide a tongue;
monkey bars that split into two then back

to one, one of the second graders,
by chance, said looked *like a blue bootyhole.*
Tell me what was I to say to her smile
& simile I knew was lewd but true?

That is, if the butt crack is a ladder.
What was I to do with her rascally
laughter, her classmates giggling beneath
their breath. I didn't frown, disappointed,

but sized up her grin that could turn a tree
into woodchips & said *beavers tail-spank*
to dam streams. No. I squatted & sighed
Sunshine, keep that between you & your drawing.

III. *Exports down a Manmade Channel*

My favorite, which all teachers have
unless they're all bad, was afraid of water.
River. The port called Catoosa we learned
tears Oklahoma from the term *landlocked,*

& connects their ruddy frontier to mine.
The dock was off-limits, but we tiptoed
the balustrades to watch barges siphon
dry goods in bulk for their route downriver.

The water looked like chocolate milk.
We toured the towboat for show, hung from
chipped rails & yelled *ahoy* from the bridge.
We all had a chance at crew then captain

to imagine sailing down the Yazoo.
To imagine ourselves as a shoelace
threading the locks & dams until one kid
yelled *snake,* & all of our fears gave chase.

IV. Living Wax Museum in the Cafeteria

After what's tragic, comes comedy.
Laughter. After the massacre, they turned
internment into a theater.
I passed every day. On my way

to nurture the importance of nature.
To the school named after the building from
which Dick Rowland bolted. Where as part
of their Black History Month programming

both Black & white kids dressed up as famous
African Americans. Jaylon
is not Emmett Till, I tell myself. Not
old enough in his oversized button

up & fedora. Not every statue
can be Langston Hughes. Tape mustache. Plaid suit.
I kneel, press the button & Jaylon speaks:
I was born in Chicago ... I died in ...

AMAZING GRACE

Behind every Black choir is a white man.
An oil-painted, oily-maned Jesus. Yes, a token
of the colonizer's appreciation for our work
songs. For the hymnals & hymens

of our fugitive relatives, & pews mainly made
up of Afro-crowned sisters & brothers
who shout *alright!* & *c'mon nah!* shaking
their heads at the mechanism we call *chuuch.*

In the film, Black folks are dressed to the 🕇
when Ms. Franklin walks in all silent
movie like a teacher who don't take no shit,
& we can't tell if it's an act of diva

or deviltry, of humility or the hum
the word & gospel begins with. The Queen
of Soul almost seemed to hover in
her robe, her father's Father's house, rooms

her chords grew up in. She looked just
like a little girl who'd broken from her chains,
like a spirited savior sweating blood.
Her father daubed her face & the Steinbeck

that helped her carry the melody & cross
her legs aloft the dais, too dazed for two days.
& on the third, she rose from her bench.
Ascended the middle aisle, Gentile yet again.

THE CIVIL RIGHTS MUSEUM DESECRATES
THE MEMORY OF DR. KING

With the junkies & johns banished, the pimps & peddlers
& prostitutes all gone, Jacqueline Smith became the last vigil left
on the corner of Mulberry & Butler. Same site she's stood,
sat, slept since she was evicted, as in embarrassedly carried off
the premises of what was the Lorraine Motel twenty years after
King's assassination. I, along with nearly every other tourist, took
photos of the wreath hung from the freshly painted banister
like a piñata. Of the balcony where the Memphis Grizzly's
re-enacted Abernathy, Bevel, & Jackson's pointing at the shooter.
When I interviewed Jesse Jones, son of T.O. Jones who led
the sanitation labor union, he said *How could the fire department
make it to the scene before us when we were five minutes up the street
& took off running towards the gunshot as soon as we heard it go off?*
Slumped, he rubbed his head like he was *polishing a dream.* As if
to say, we know the response time in the ghetto is nothing
less than disrespectful. We traded scenarios in his living room
the way Black Nationalists might've sat crafting their next moves.
Jones went on to say he was just a kid running up & down
the aisles of the Temple when King delivered his last speech.
That King looked weak from the moment he took the podium,
& that the minute he stepped down a downpour thundered,
just as it was raining the day I went to interview Ms. Jackie
& found her under an umbrella radial enough to fit two radicals,
or one & me. A blue tarp smothered her table like a sheet
draped over the dead, but not its petition: *Gentrification is an abuse
of Civil Liberties.* But by the time I crossed the street & the lot
to what she coined as the *National Civil Rights Wrong Museum,*
a crowd of high schoolers appeared, waiting to listen to the black
bonnet & shades state her mission & mention the days when
she was a maid in the motel, when the dream was still alive
& somewhat well. When the rain slowed, a line snaked out

the entrance to the museum she boycotted before I was born.
Somehow between seasons of street politics, she had a daughter.
Someone between sunrise & sunset brought her styrofoam
clamshells. I sat on her pew as she ate over her selected readings
of *God's Long Summer* & *Mine Eyes Have Seen*. She ate through
museumgoers, ate through our interview, ate until she felt
full, then, with black thumbs to white latches, closed the casket.

OUR HANDS ARE BOWLS OF DUST

North Tulsa, Oklahoma

Ask the lord why he commanded us to turn
all of our grocery stores into churches bestowing
no fishes or loaves, but rather mite-sized wafers
for our faithful migrants & migraineurs waiting
in the rafters of raffles & MLK protest fans,
waiting to be filled with what's whole & holy,
with a provision that prompts tongues to act
out a quaking that only occurs in starvation.
Ask the lord if a food desert may refer to a fast
a follower has no say in. The devout disciple
led into the wilderness with a Bible & salivation,
halos, hallucinations & hallelujahs, driven to
the drilling rigs' pinnacle to turn not a stone
into sandwich, not a pit into olive. Ask the lord
if it's okay to swallow shadow critters bowing
beneath the stones. The worms that are symbols
of both catch & bait, pill bugs that represent
the pea. Lord, I've wandered where the chosen
have been pushed hungry as a pack of black
sheep & all I have to show are my tennis shoes
cured with sand. I'm sure that we're the salt
of the earth because of the flavor that falls from
our flesh when we walk under the sun. The way
our skin sears till we disappear. The pews may be
filled with a few but we are mighty. Our stomachs
growl like the lions they are, from when we enter
the sliding doors till when we exit the tiled aisles
to broil, praising our lord with the sweetest aroma.

HEADED NORTH ON THE MIDLAND VALLEY RAILROAD TRACKS

ELDORIS MCCONDICHI (1911-2010)

Shots rang out like a cowbell.
Shots rained down on a tin roof.
Shocked, I broke away like a
Shock of hair, left my parents
Shook. I hid inside a chicken coop.
Shook my head with the others
Shoved like chattel till my father
Showed. He spoke with the whites
of his eyes. We passed shed after
Shack with all the other shades of
Shame in night gowns, head wraps.
Shaken, some folks walked without
Shoes on. Some walked so far
Sharecroppers started cropping up.
Shucks, a white farmer stopped us.
Shouted: *as many as you people can*
Should head on in with us.

MOVE-IN DAY @ THE REFINERY

You are here * Exhausted * Brand new apartment * Having brought in most of your belongings * Longing for the loft-warming gift from your first friend * Always pack books in small boxes * She contends * Always * Obnoxious train * Traffic * Trolley * You stick your head out the awning window * Toward a U-Haul Self Storage you learn also burned * On its roof * A swiveling * Twenty-six foot truck * Trailer * Truss of string lights * Star of Bethlehem * David * You bring up the rest of your stuff barricading the elevator * Gifts at the foot of a balding tree * Massacre * Afterwards * You walk past the building * On the truck * A profile * Frontiersman * Native American man peering into the distance the way scooters stagger like geese before crossing the street * For weeks your friend will tell you the history * For months you will jump in your sleep * Headlights breach your shades * Screen * Shades * Scream * You are here

NEIGHBORS

How long did it take to paint the flag
on the ga/rage's back wall is not what I asked
myself or my sweetheart, backing out of
the driveway, heading back to where we'd

just turned, looking for a place to stay.
We were greeted by a law/n of trucks & cars,
Hot Wheels that had grown & grayed,
& the Confederate mural for us to marvel.

It couldn't have been that diffi/cult seeing
as the design is rather simple: A diademed 'X'
of thirteen stars, an intersection of dreams
& the red that surrounds it: the red text,

the red trucks, the red necks, the red rust
pointing to the odd of it all. A single man
could've pulled it off. Could've brushed,
or rather slathered pain/t from canister

to wall, but two stories means family.
So I picture a wife drafting the southern cross
& kids filling in the s/tars. O' say, can you see
an open garage aerating the latex exhaust?

Neighbors walking their children, pointing
past the ropes, shovels, ladders, saws?
Racism takes teamwork, takes the anointment
of offsprings. I can almost see their gaw/king

once the wall was finished. The man kissing
his wife's temple, both with one arm around
each other & the other around t/heir kids.
That day my sweetheart & I agreed the mounds

of the midwest were no place we'd want to live.
I guess the image could've existed in the house
before they got to town. A backdrop whistling
"welcome niggers" they'd failed to take d/own.

NITROGLYCERIN,

a yellow liquid of nitrating glycerol,
may be administered to combat
angina by widening vessels to the heart.
Nitroglycerin has also been deployed
in combat to destroy entire districts,
as well as erectile disfunction as
it caverns vessels such as the inferior
vena cava that extends from the groin.
When I was admitted for palpitations
& sharp pains in my head, the head
cardiologist said my electrocardiogram
read I either just had a heart attack
or was about to. Nitroglycerin may help
you relax, but may also backfire, instead
igniting a heart attack. Nitroglycerin
& nitromethane are not the same.
Nitroglycerin to a tongue is like a key
to a doormat. Nitroglycerin gel works
vastly faster than Viagra &/or Cialis.
When I floundered like a flounder
out of water, my lover dismounting
my shudder thought she'd killed me.
Nitroglycerin, when taken properly, can
reduce chest pain caused by vagina.
Nitroglycerin should be taken before
aspirin or any aspirations for an encore.
If taken with alcohol, the side effects
of nitroglycerin may be even worse.
When an Osage woman was found dead
around the same time as the massacre,
her first cause of death, before they found
the bullet wound, was alcohol poisoning.
An abuser can overdose on as little as

200 mg, though records show a man
survived 1200 mgs like it was no sweat.
Medicinal nitroglycerin is neutralized
by sodium chloride. Do not be concerned
that the tablet is not working if you do
not feel the burning or tingling sensation.
When an Osage couple's house in Fairfax
was detonated for affidavits or head
rights, the culprit disguised as a neighbor
stated, at first I thought it was thunder.
Nitroglycerine produces a glistening
that can be seen from many miles away.
Nitroglycerin is used in demolition.
Nitroglycerin is used as a gelatinizer
for nitrocellulose in film reel production
which happens to be highly combustible.
When a white motion picture operator
at a Black theater asked the manager
what he was going to do with his gun
he replied, "looking out for Number One."
Nitroglycerin is the base in double-based
smokeless gunpowder. Nitroglycerin
is available in ointments, patches, & sprays.
Nitroglycerin is not over-the-counter.
Under the table. Nitroglycerin can
be applied topically to treat fissures.
When an Osage woman was taken
off insulin & started seeing other
doctors, her maladies magically went away.
Nitroglycerin is toxic. Nitroglycerin
inhabits, thus inhibits the liver if taken
intravenously, similar to alcohol if taken

extravagantly. Unstable nitroglycerin will
not endure any galavanting, but explode.
Nitroglycerin between forty to fifty
degrees Fahrenheit will desensitize.
When I perch my right hand aloft
my heart, it's hard not to think of a wing
flitting like a flame's little death.
You should know that nitroglycerin
may cause dizziness, lightheadedness,
& fainting when you get up too quickly
from a lying position, or at any time,
especially if you have been drinking
poisoned alcoholic beverages. Take extra
precautions to avoid falling during
your treatment with nitroglycerin.
When I lie awake it's sometimes difficult
to feel anything. Infrequent exposure
to high doses of nitroglycerin can cause
severe headaches known as "NG head"
or "bang head." Withdrawal can be fatal.

RECOMMENDATION

Try not to discover religion too readily
& Cubanos not soon enough. The first time I fed
on the buttered crust, Swiss cheese, sweet
pickles, yellow mustard, & roasted pork delight
I might have blushed. Might have bled from
beneath, rushed to the surface certain of my beliefs
in the spirit of giving myself over to pleasure.
In the seats next to mine, a double date
of dashikis ate a soup the color of mud & chatted
in a coconut rich accent. Just the scent
of Tampa's signature sandwich makes me crave
the sludge my ancestors wallowed in, though I try
not to let my desires fester. However, from
time to time, I do form an itch for a lover
darker than a lower deck to peck me from hoof
to snout after she's chewed a few strips of thick-cut
sow in order to sooth my cracklin' skin with her
anointed lips, but my sweetheart refuses.
She quit consuming what Muhammed considered
the white man's pet when her granddad,
greatest grill man in Memphis, perished in his sleep.
When I die, I want whatever devout pescatarian
that outlived me to place my carcass into one
of those gargantuan BBQ pits, that way if my relatives
happen to be a couple of bones short of casketing
my corpse they can singe me into ashes after
removing the andouille that usually ends up scorched.
If it smells good, you should give it a try,
is hardly my advice. Ever since my heart cath
I've sacrificed bacon grease for olive oil,
but refuse the "salt" my grandmother struggles to use.
She grunts, it just don't taste right, between placing her
teeth inside an old fashion — manilla on the rocks.

If you're white & want flava as opposed to flavor,
try cooking in bacon fat. Vats of lard date
all the way back to when the Lawd became flesh
& banished a pack of hogs into the sea
just to be waterlogged, which may explain
how the rooters made it to the U.S. in the first place,
though I'll believe it when swine swim.
Thinking about it, Guinea pigs from New Guinea
does kind of make sense if you quit thinking.
I have folks who hock spit at hamhocks, also
known as the pig knuckle because of its mucous
manifesting ability. For several years, the joint served
as provisions for the indentured. Seconds.
I'd reckon no one who's Muslim or Jewish would dare
waste a perfectly plancha-pressed Cuban sandwich
if they were unaware of its ingredients
& greediness. If you go without pork for awhile
& then order a side of southern green beans
do the bits of sin signal your tongue to ring
your throat? Swing the uvula that droops like a nose
drip of the all-knowing European? All praise
to the tusk-toting, husk-bred idles, but no appraisal.
Folks who've raised the slop-eating varmints
Muhammad called a mix between a cat, rat & dog know
their worth & their god. Know how much
it costs to import our hearts into their cages.
To ship disease from one mother land to another.

MALT O MEAL, SINCE 1919

While Post Consumer Brands was just getting started
"Making delicious hot wheat cereal," serial-killing sprees
By white mobs experimenting to see if Blacks bled
Plantation *Organic* Blackstrap Molasses were also underway.
Which having tasted the iron, potassium, & calcium-rich
Refinement, I can rightfully say it will keep you up all night.
But not the type of up that produces offspring off
Bedsprings (though children will keep you up as well),
But Bigelow Plantation Mint Green Tea up. I'm talking
Turning in your sleep Br'er Rabbit popped collar, bowtie,
& the Tar Baby up. Not jackrabbit or Roger Rabbit up,
But Bugs Bunny top hat & tap dance up, Michigan J. Frog
Belching ragtime up, Owl Jolson "I Love to Singa" up,
With a cheer for Uncle Sammy and another for my mammy,
& I'm thinking of all those Looney Toons I watched
As a pup, or the pup we had until he passed from a disease
His mother passed down to him & the rest of the litter.
I'm thinking of you too, Ma, in the kitchen microwaving
Malt O Meal, the *Malt* for malted barley, the *O* for ferric
Orthophosphate or the shape our mouths make when we wake.
I'm thinking of the last conversation I had with my sister,
How she asked, *Why didn't we just have oatmeal?* Wondering
If it was because of some government subsidy we had
No idea we were receiving. This morning, as I stir
Cereal from the first box of barley I ever purchased,
I'm thinking of how we slurped it up like warm baby food,
How it sometimes splatted the bibbed napkins that fell
To our laps leaf-slow if we made the slightest movement.
Aunt Jemima tells us syrup is thicker than blood; Uncle Ben
Carson, muted; Rastus from Cream of Wheat says, *Costs 'bout
1¢ for a great big dish,* & with the nostalgia of how good it was,
What with the puddle of cold 2% milk, warm margarine,
& the whitest of sugars, I shovel & shovel until it's all gone.

WHEN TULSA NEARLY KILLED QUEEN

for Patricia

The Magic City is a sousaphone player drowning
out the patrons of a *Mexican seafood* restaurant
shouldered on its outskirts that if I drove Patsy

promised to take us. The back of her hospital gown
was shucked elote after she'd fallen to her knees
clenching her chest, stabbed with a letter opener

of indigestion. We'd found ourselves in the ER
after eating the acidic dinner I prepared & seconds
in what had to be the wealthiest part of town,

found ourselves speeding through a tunnel
of oak trees, sputum sluicing through valves.
My job as host was to keep the renowned wordsmith

away from wine-sipping, cheese platter white folks
who wouldn't have known they were turned
around or speaking out of turn if we told them.

To calm the slow burn of a scheduled book signing
with no books, only after the university's finest
mistook her for a white author who shared her name,

only after we caught him rattling off a Wiki page.
The Magic City is a sousaphone player in need
of a plunger mute. In addition to each other's faces,

we watched the tables closest to Señor Sousa
frown through every chew of their chips & salsa.
We watched servers juke out of his brass path

that wrapped around his torso like the large intestine
of an exoskeleton. Gastroschisis is nothing to turn up
your nose at. Patsy is a poet, but the lab coats

& scrubs were too busy kissing her breasts
with a cold stethoscope to know it. Much too busy
checking her temperature & not her temperament;

listening for key words to hear the keys her words
fell in. The vibrations similar to what made us shake
our heads at the Don Sousa with the nerve

to blowfish into a microphone as if his flared, blaring
flatulence wasn't wrong enough. All of this away
from the Inner Dispersal Loop that cuts through

Greenwood like an arm raking a Blackjack table
taking all the land it could. All of this on the outskirts
where the population resembled what Patsy was

used to in Chicago's iller noise. The brass of funerals
where second lines dance & play at the same time,
or the soirées of Grand Couteau where Patsy stepped

on my toes as we swayed & twirled to zydeco
beneath a canopy of bald cypress & small-talked
old, white women in backward trucker hats,

only this time with Schnozzlephone & a platter
of broiled shrimp-scallop-&-octopi-stuffed lobster
for two. This time with our cheeks too full to talk.

Best believe, we drank to hyperacidity, toasted
to garlic toast. The loudness made it feel like we'd sat
next to the DJ booth at a wedding reception

to the point that I couldn't make out anything
Patsy was saying without looking away & bending
my ear to our shared plate like a kitchen expediter.

Neither the man at the bar flirting with the server
or joking with his daughter, nor the saucers stacked
like the skyline that when we left the restaurant

seemed so distant we thought we'd never get back
to the "Inner City Blues" of the Inner Dispersal Loop
that throttles downtown like a king cobra choking

a mongoose; or like a sousaphone burping so loud
I could barely hear the "death-obsessed" poet report
"Tulsa is a beautiful wedding gown on a corpse."

A BABY WEDGED BETWEEN TWO BUILDINGS

baby swallowing & swallowed by
downtown baby wallowing in crude
cradle baby groundwater baby
soup ladle baby aquifer not a martyr
baby pacify the city with oil paint
baby deposit not mature enough
baby can't withdraw till dry baby
baby future of tech hub baby texture
of tetris baby ultrasound baby
turned to side baby baby baby
can't stretch out baby heat map
baby not crushed to dust just yet baby
burned with structures that rose from
concrete steps mushroomed even
the hate u give little infants fucks ecology
everybody was not accounted for

MAINTENANCE @ THE REFINERY

You are here * Peck at the door * Upkeep manager * Upbeat * Blue air filter under wing * You like how the upkeep manager takes care of business * The old filter is spotless * Even when there is no business * You like that the upkeep manager asks about your stay * The old filter is always replaced anyway * The upkeep manager is conscious of your time * The new director arrives fashionably narcissistic * From then on * The blue filters are leaned against the doors * From then on * Anyone who gives feedback at meetings is seen as a menace to their art society * From then on * Anything you say to the upkeep manager in private is made public * From then on * When the upkeep manager asks about your stay you think none of your beeswax * Hot water heater * Gaslighting * You try your best to stay out of the hallways * To sneak past their office that shares a wall with your studio * Though soon even that will go * Soon you'll rarely leave from your window filtering the afternoon's filthy blue * You are here

MY FELLOW GENTRIFIERS

for Anna

The downtown feathers are clever in the ways they erect
their nests. No, they're artsy, no, cagey. Balloons stitched
in their typhoons. Key to the citadel, scissor-tail to cut
the ribbons. The downtown wings are simply ingenious,
no, ingenuous. Roosting inside buildings & deciduous
trees. Inside clinker-brick rooks in drive-thru cemeteries
where visitors are greeted by a handless Jesus, & statue
of two doves nibbling each other's napes. They take shoe
laces that didn't make it over power lines, pink & blue
hair ties, fasten our limbs to a spit & roast us over fire.
The downtown talons are talented, no resourceful. Sharp.
Sharp. Shark. No, foxy in their Red Wing Boots. Right
wings. Wily in how they swoop down, carry off, carry on.

WORLDS LARGEST PRAYING HANDS

For God to hear your prayers he needs to see your hands
Together like a mosquito's gazebo carrying your blood
Like a message & massage after acupuncture to another
Mediator buzzing in the ear of both pastor & al pastor
Who says he has seen the 640-foot Jesús heard the word
Of the Lord before delivering what he scribbled & erased
From the margins of the same verse everyone has heard
Before while his wife sleeps her hands clasped between
Her clasped thighs because she hasn't been touched by
Oral ever other than the tongues spoken by the ordained
The forehead nudge that sent her backward in convulsion
On the pulpit in front of the whole congregation busting
The snake on the carpeted alter where the true believers
Shame the naysayers catching The Ghost the most divine
Sign of the times & tithes the offering basket passed over
By the pastor ten percent all the church & school needs
Ten persons to give whatever the pastor-in-training puts
On your heart a small tax for the absolution of your sins
For your single friends who found love in thy neighbor
Sitting in the pew next to them the iron gates ticking open
Once the code (5646-316) is typed & the reverend enters
By his lonely his rectangular spectacles readying the first
Sermon of the second Sunday at the Third Pentecostal
Methodist Methodical Methuselah Televangelist Church

RAWHIDE

for Heyd

For you — I'd model — pose like Frank Ocean on stage,
on stool, peppermint kerchief, singing *thinking bout you*
not nude. Sorry bud. The thud of buckle, my pants
crumpled over my boots like an accordion or the torso
of a bus will not be televangelized. Clothes are the graves
we step out each day. The coiffure's fallen by the way-
side. The air blown in bones to make us soldiers again.
Our joints soldered together. Ligaments of literature.
Ligatures! & all words are bent over-knee, thrown, come
back to crack our skulls, my Chatter Grin, my Overbite.
Both pet names & livestock end in slaughter. Why fall
in love with a farm save the home-cooked meals? Save
our sassafras — sausages? Save knowing where everything
you eat is grown? The value of hard slop that cuds in
one end & is herded out the other. The knives & forks
fencing. Battle between cutting & raking into your maw.
Your Ma who prepared it all — your bookend brothers
& smarts included. The coop & barn out back where you
first learned the slapstick of nakedness. Of two men
breaking against each other amid all those eggs & utters.

ESCAPE ARTIST

Google *Sarah Page* & you'll get
Page after page of Dick Rowland,
Inextricable, like the days when
A wife was known by her spouse.
Save for the rumor he only knew
Her, biblically. *Diamond Dick*. As if
Page, her "Daddy's" last name,
Never existed. Goggle the graves
At Oaklawn Cemetery. You'll find
One that reads *James Jones*, born
Around the same time as Rowland,
Roland, the former a clerical error?
He who died two months before
The massacre. According to Wiki,
Rowland or Roland is only two
Years shy of the line God drew.
Innocent. In the sand. Guilty. Gill
Tea. Whereas Page clapped her
Ruby flats together & poof, back
In Kansas, or poof, "Little Africa"
Up in flames, or poof, a blackout,
& an orphan is wed all over again.
Page, the Houdini of who-done-it?
Roland, a contemporary of Black
Herman, or VanDerZee's *Escape
Artist* festooned in chains, shackles,
Ogling cockily into the camera.

REFLECTIONS ON REFLECTIONS OF EL LISSITZKY

If the police never did wrong, people would trust them.
*Nobody ever made a song called "f*ck the fire department."*
— Snoop Dogg

To test if a firehose is working properly / I once saw firefighters lead their truck to a river / like some oversized / dumb red dog overalls hang from / & run the water through the hose then back / into the river like a pissing boy / too tired / or shameless / to care who's watching

The first time I saw Theaster Gates' *Reflections of El Lissitzky* / I figured a firehose was retired / on the strength of something too large / lodged in its throat / that needed to be cut / from its stomach & so rendering it unusable / Not because they were made of cotton / that once ruled everything around me / now ruled as weak / but because the hose stopped / working / making it obsolete / Obstacle in the street / speed bump bump bump / Once / in West Texas / I pulled over to take a pic of a moon / my passenger / seat / might've assumed was the sun's second coming / Parked beside a field of cotton / that same passenger seat might've mistaken the flowers for slavery's third / fifth

Even without sirens / firemen whip by like ice cream trucks fresh out of Bomb Pops / In the massacre / massa / mass / acre / sacré bleu in green / firetrucks did not stop to extinguish the anguish / or were stopped / by white mobs that waved / them off / or talked them into turning / their backs or watching / what they might've seen as the glory of a burning bush that wouldn't kill them / to look on at the siding falling off the frame / like meat falling off the bone

"A God Walks Into Abar" / beque joint / like a joke / A god walks to the bar with a firefighter perched on every stool / The smokers have all but retired / so they offer the god what they call their refugee plate / which they offer to those who are late / The god wants to be entertained / but the sports announcers on the TVs have all retired / The

god wants service / but the staff retired into their tunnels / The sauce has retired / The water pitcher / retired / but the god is thirsty

The second time I sawed a bar in half / I noted Gates described the sculpture as "decommissioned firehoses on wood" / It was inside an oil tycoon's estate turned museum / The faded red hose completely engulfs the wood / I imagined myself inside a burning house / the smoke filling my lungs / like a tank to hold the spirit of the fire / until the tank could no longer hold its own liquor

U didn't fork it about Greenwood did ya / Any residents who chose to fight / or not evacuate / were escorted / escargot / shell in back to three internment camps where their employers had to vouch for them like kids in a nursery / Greenwood residents were given green cards so they could pace from where their furniture was to where their houses used to be / Well-known surgeon A/C Jackson / surrendered but was still murdered / by a boy who was either too tired / or shameless / to care who was watching / Another man fled his burning home just in time to be shot & thrown back in / like a log rolling away from a campfire

I'd be too / worried about a dog choking / to give them a bone / K9s are owned / & only useful if they bark / Bite / Just as a hose must be neither crimped nor clogged / if an officer truly desires "crowd control" / I loathe those videos where we're pressured into establishments my people were never allowed in / Bloody pigs with their bludgeons never budging

Five "Riot Pennies" rescued from George Monroe's burned home / are now housed in the Smithsonian / Some are so char / red / you can only make out "Rust" & "Go" & "Stat" / Some you can't / even see the parentheses of wheat / The copper melted over / Maybe it represents not one victim seeing a single cent of justice before judgement day

The third time I was what Gate's calls "Civil Tapestries" / I thought I needed a larger room to be appreciated / Enough distance to survive / survey / & keep the fire at bay / Online / I've seen firehoses turned into lawn chairs / koozies / picnic supplies / There are wallets & belts & purses & don't shoot the messenger bags all made from the same textile / Cotton: so polyesterday

I straddle the tracks that divide Green / wood from the rest of the city / look north until even the rails disappear into a distance that becomes itself a kind of fog / Until I start to make out the tracks' / dream of being a ladder with the slight lean of a distance runner / Their dream of saving somebody / anybody / a dog / a child / even a man / I slip inside the dream of the hose / A firefighter's desire to fight what could reach out / Though Jack Gilbert says "We are wrong. The wood reaches out / to the flame" / I try my best to understand the ground is better to not look down upon / like the firefighters who racing to Greenwood found it best to turn away / to not look back lest they see a part of themselves in the burning houses / & if not the houses / the mobs that stood on / astonished by the theater of burning / knowing soon it would all be consumed / anyway

MURMURATION @ THE REFINERY

You are here * Watching starlings make cursive the air * Now you are here * Aloft the balcony bathing in their waves of cones * Golden hour * You are a stare mistaken for a glower * Watching the synchrony of starlings fly over the sin * Cronies * The vortices collected then dispersed * You are not doing work * You are watching the funnels heave into other shapes * Your arms too short to box with god * You are watching the long arm of the lord * The other arm that builds instead of destroying * The storm * The cloud * The swarm * The loud chirps scientists have not found to communicate their simultaneity * The birds * The deities * Sipping a cup of naivety * They say a tornado sounds like a train * The starlings fly over the tracks where the majority of violence took place * Takes place * You hunker down in a small hallway with fellow fellows waiting for the sirens to silence * Waiting for the thunder and their Labrador to do the same * You are patient * Bark * You are eye * Bark * Calm * Bark * You are here

SAND SPRINGS

We take the Katy Trail, me & L, that runs cheek
by jowl with the Sand Springs Railway stitched over trestles,
through trees, through dilapidated back streets
where other bikers forewarn of woofs with no leash;

a break from the bush, where an 18-wheeler flagged a friend
a fag before honking & running him off the road,
a 2D toad. We pedal past Whitey's Pawns & Tools edging
a sky that appears to want to swallow us whole,

some miniature "Den of Terror." Subversive? The owner
snatching up gadgets & other whatchamacallits
from whitey who sells what his wife no longer wants
to see. To eke out something that reeks of torture, or didn't

belong in the merchant's home in the first place.
Some contraption to fix the sink or the "Black problem"
brought on after the exodus of Greenwood residents, a rash
that stopped spreading but never fully went away. Sodom

of the state. We look both ways for each time Peter
was caught lying, before pushing off to pedal past the sign
white as a milkweed's puss; some ointment advertised to cure
migration, announcing to the locals with pitchfork tines

"this is where you shall purchase all things worthless."
The loading dock both stage & prop. The parking
lot weaponized by the rocks that seemed to engulf the tracks.
"AMMO," "KNIVES," "GUNS," "TOOLS," "JEWELRY"

& "GUITARS" decals, along with the acrostic "LOANS"
painted down the door like an unwritten poem on debt.
I just wanted to ride, but L wanted info on the town's founder
Charles Page. A klansman who would've shouted

"Leave them alone" to rescue victims from his own conniving.
To change a topic the perpetrators could care less about,
standing guard in front of the homes Page built for old wives'
tales & widows, divorcées like Sarah Page who stepped out

like children abusing the frame of a torn screen door.
We stopped for donuts, to see the statue of a lad extending
a bouquet to a lowly woman, & bronze Page brooding over
the sentiment right outside of his eponymous library.

We were too tired, or too set on heading west, thus missed
the other library illustrating a train hauling a coal hopper
like a driver dragging a Black man by his neck because
he believes, though not slaves, we should still wear ropes.

But Daddy Page made sure they all had their places.
That no one was harmed in the making of his alibi. An empire
of orphans going out to fight the good fight of racists;
to be lawyers & doctors, swindlers & proctors,

elevator operators even, while the widows knitted
robes in some unorthodox sweatshop. It could all be true.
Their hands working the cotton, cutting the sockets
just so. Just so their eyes were only one color: Aryan blue.

The rest of the getup white as gesso. It could all be a lie.
We know. & knew we needed to get back on the trail
if we were ever going to hit the road. I caught a flat tire
outside of a barren city, but I'll have you know my trial

on the backroads was not in vain. That I humped the tube
all the way back into town like some fool who thinks the heart
is an unnecessary good. Blocked rails, arteries. No food.
How it accelerates uphill. Slows only after you're thrown off.

THE GOSPEL OF JOHN THE BAPTIST STRADFORD

Better to cough up water than sweat blood
I never say. & I'd imagine
neither did the ice man that called Stradford
out his name. The ice man, who if it
were today, would be known for his racist
comments. Not so much his tongs but his tongue
one might've believed had gotten stuck on
dry ice as a child, & so conditioned
by way of brain freeze to say whatever
came to mind. Though even as a Negro
in the era of hyper-surveilled errors
Stradford felt he owed it to the ice man
to whup him in the middle of the street;
to beat him royal, swollen with irony.

TO: ABOARD, FROM: ABROAD

Baby, to be honest, I don't know
what I'm doing. Your voice wails

like a train trying to clear a track,
& your eyes have crossed to one.

Truthfully, I found it hard to tell
what the trees & folk that settled

in the south's blurred backwoods
were waving. If they were saying

hello or goodbye. If the pastures
where they stood were the front

yards or the back. My mama said
that if a lover hops a freight mid

summer & tries to return late fall
to kick them where their hat lies.

She said go for the nose to derail
any blood that even thinks about

going to the brain. I believe she's
rightfully crazy. Remember when

we rode that train to Tennessee?
Our faces in the glass looked like

a photograph we should've taken.
One, once years passed we could

look back on & laugh. Baby, take
me back. Those wheels humping

the tracks across from our shack
are nothing but chalk-dust to me

now. They've wrecked my bound
& gagged baggage, then dragged

over it one mo 'gin to make sure
my dignity couldn't be salvaged.

We both know I could never tell
the difference between a horse's

cab & its caboose. What I mean
is, I loved your face just as much

as I loved your sweet ass. I know
it may sound bad but it's the god

fearing truth. Hear me out, baby.
I don't care 'bout looking like no

sick puppy in front of you, 'cause
when I peek at the picture I keep

stashed in my nightstand, I can't
help but want to be the scalawag

with his lips pressed against your
cheek. Holding you from behind.

THE JAZZ HALL OF FAME

Much of the crowd exits following the two hour jazz session
of Sheila stretching her sax as far as it can crack nearly bleeding
on the reed, but the true Bluesers & bruisers, the ones who show
their faces without a date to swing & twirl like a bass player's
first girl, the ones who'd like company on a Tuesday evening,
even if it's a handshake or a smile from the biddy behind the bar,
these are the ones who plant themselves in the cracked tile,
their toes stretching out their huaraches, down to what was once
the depot, these are the people who know mute is a sound,
that there survives no melody as sweet as heartache, as the ditty
that takes you back to what you're imagining tapping your toes
almost to the point where you reach out your hand to what's not
there, to the one you swayed with under a stand-in for the moon
while waiters & bussers picked & packed up like a band gathering
their instruments into the cases shaped to hold their figures,
into the warm velvet darkness, carried across shoulder, across
puddle, & this is what they get, the adrenaline all over again,
the cheek brushed with a *little doodad*, & it's too bad isn't it, too
bad it didn't work out, and time is pitted between like a train,
steady thud to the drum, the wheels & their squealing, the bolts
coming undone, stiff braids of the rails, their telling of what's
arrived, *& in my eyes too*, I begin to envision who, what feels like
just the other day, was so close behind that had I straightened
my spine I would've backed into her face, her arms, & would've
stayed there, warm, my eyes clenching their shells, my hands
in closed position, would've asked baby, can we just take it from
the top, from the old heads of the drum, knowing some things
we can neither forge nor forget, knowing regret is a spill you knew
to catch, that fell in slow motion, but not slow enough, it's never
slow enough, a 4/4, the sticky floor, the sole that must tear
to getaway, & I understand the morass of lying in one's own
exploits, & how even with the undertones of grief there is a sort
of solace, a consortium of consolations saying look at the world

I've made, how constructive comes after disgusted, or how
you could just slap yourself for playing the fool, for thinking
the conduits of your palms could hold such fluid, such ruling
that warps to whatever shape it fashions, & why can't your breath
graze each valve, make brass shudder before stutter, & how does
one remake it back outside of the covers, the band who's played
each Tuesday for years, the crowd that has grown & grayed
with them remember the very lines of each song like the lines
in their faces, the way a lover won't except when they simper
at pictures framing a time that wouldn't stop, a 4/forever, the time
they wished didn't quit unlike the singing in bed that only peaks
at amateur, sleek diesel, which is what they, we want to be, gassed,
revved to the point that they, we forget where time went, heads
nod not in sleep, but reverence, river rinse, in genuine adoration
of the music that has made them feel young again, you're young
again, tasting the sweetness of kiss after kiss, the foolishness
of desire, a dancing not even death could snap them out of.

SOUTHWEST SWING

Got my bison license plate
My big blue sky and my red clay
I staked my claim & lynched my shades
'Cause I'm the vein of Oklahoma

Got my cleaver killed my state
I still believe in god we pray
We burn the buildings that we raid
'Cause I'm the vein of Oklahoma

Got my flag for thirteen states
We're headed where the Negros stay
We'll call our march a masquerade
'Cause I'm the vein of Oklahoma

Got my crossroads & my bait
Before I slave I look both ways
I truss their limbs & make the trade
'Cause I'm the vein of Oklahoma

Got my bomb to detonate
I should've died like James Earl Ray
Or drowned where all the Baptists wade
'Cause I'm the vein of Oklahoma

Got Coronas for my fate
Drove my Corolla till I strayed
The coroner hummed to his sweet blade
'Cause I'm the vein of Oklahoma

'Cause I'm the vein of Oklahoma
'Cause I'm the vein of Oklahoma

SUGA WATER

for Manley Crew

Think of the movie *Cool Runnings,* only
on water. Of the idiom four peas
in a bathtub; four young, strapping Black men
competing in a pastime history
contends has no business attracting us.

Instead of a gun, the start was staggered.
We christened our coxswain Whiskey Tom,
because he kept a flask in his backpack.

Within the first five minutes of our first
out-of-state regatta, we collided
with a mindless motor boat, but knew it
was the fault of the shutterbug skipper.

This was our first time in *okla humma,*
our second race north of the Red River
that gave the state its serrated blade.

What came first, the tomahawk or hatchet?
I'd say, not the most sensitive question
to ask. I should note we came back from
whatever place we landed after crashing,
but knew staggered meant time was against us.

& so, Whiskey Tom roared "power twenty"
until my legs felt like fish puked ashore.
We buried our oars & rowed past one white
school after another to no avail.
Our early run-in had accosted us
in the way that it cost us the race.

But what made it worse wasn't that well past
the finish line *someone* caught a crab
& overturned our boat, or our soaked
row back to the docks, as the sunshine
decided to hide our novice mistake.

No. What made it worse was Whiskey Tom
charging that we lift the shell overhead
& the gush of shame we couldn't escape.

OKLAHOMA NEEDS AN NFL TEAM

Labor conquers all things — *Oklahoma Motto*

Like a fumble or an onside kick,
opportunists charged to dive on *said* allotments,
to smother them like a small fire, the smoke
signals rising like swift-dissolving blimps.

A lot went into securing the acres
on & off the field. The trampling more severe
than any doorbuster. The player's aching
much after the most gobblingest day of the year.

But it's far too late for Sooners,
& there's only room in this nation for one
Cowboy. What about the Oil...that's Houston.
The Pumpjacks? How about we give it a foreign

moniker & market it on all the marquees
from the majors to the park leagues?
I can see it now: *The Panhandlers*
vs The Panthers, Monday Night @ 7:30 CST.

Let's call the stadium "No Man's Land"
& not show up. Let's take a knee to something
vital, cross our hearts & other organs.
Oh, & how about as part of overtime,

the kids whose parents dressed
them up as freedmen & cowpokes can stampede
the banner in a race to the insensitive mascot
at the *pow* of the musket & *wow* of the crowd?

BATTLE GROUND @ THE REFINERY

You are here * You are peering out of the window you appear * You are overlaying overlapping the tracks where the majority of violence against the minority * Your peers took place * Takes place * Objections in the mirror are closed * Objects in the mere case of nearsightedness * You wear your glasses * A doubled pane double pain in the * You are a speck in the eye of the spectacle * 'Speck on my name * You do planks with knee circles to prepare for bear crawls * Army * Arm me * You claw your way back from the dedication to fight a wardrobe malfunction function * Malfeasance * Banana chips * Banana clips * Republican publishing * You appear in sand * Insane * Insatiable * You appear in the spirit of the spear that at first lance was meant to shear the mobs commissioned to the force * Red Fork * Black beak * O' mission * Oh my darling * Oh my Darwin * You reveal but don't revere the shear force of discourse * That course * Coarse hair coerced for the cancelled promenade of fear * You are here

AGAINST THE HORIZON

Every hour or so a train tears in
like a trumpet, barrels through what was
once the depot, now the Jazz Hall
of Fame. The tracks ring louder than
massacre. Older than the land claimed
by force. Removal. It is a single-file
stampede with the stamina of steam, no,
coal, no diesel. Only night knows
the plants' pliant smolder. How muted
stacks secrete what's barely visible
by sunset. Film that filters its sin.
The town shuts down at ten, but a single
finch beckons my window, perches
on a power line, preens its disheveled self.
Its feathers are primed in dust — in what
rids the parasites, & what kills us.
The sky thins into a holographic squint.
My eyes burn against the horizon.

COPPERHEAD THAT WANTED TO BE SPITTLE BUG THAT WANTED TO BE SCORPION FLY THAT WANTED TO BE ARCHERFISH THAT WANTED TO BE WALRUS THAT WANTED TO BE CAMEL THAT WANTED TO BE COBRA

To make sure he got it — & by it
I mean spit — he kept a soup can with
him since a lad like a flask
of chocolate milk, & every time a yolk

of mucous welled up in his throat
he hawked, as in casted his shadow
over the can & released, &
because he moved the can

farther away each time it rung
cracked-belled the can never moved,
but rather drooled like an infant
sitting his lap, & since he never moved

from his rocking chair on his porch
of allied pride amidst some
midwestern town not completely sure
if it's the Midwest at all, the sputum

puddled his lap until it runneth over,
until the oak planks weren't
spit-shined, but rather distressed
like the vintage chifforobe & dresser

that caskets his change of clothes
— what with all the acid his gut accrued
all those years eating the pigs he raised:
their corkscrew cocks & cracklin robes.

PANHANDLERS

Each day he walked to the same puddle
of the shadows, scratched his head.
& each day a glassfish surfaced to inhale
his dandruff. He'd, of course, found

the fish by accident, rummaging through
his bearded reflection, or dumpsters
boredom tagged while he palleted refuse.
The delivery trucks in their summer

sighs, pissed, & kept the puddle full.
One day, the man, not in madness, began
to croon, wishing the fish would reveal
itself as his scalp throbbed & reddened.

Some pitiful notes, in that morning,
could also wake the studio apartments,
& it did both. The glassfish shimmied
close to the surface, its tail fin a thinning

fan brush, & the tenants threw buckets
of cold water out their awning windows,
their fists waving *I'm Gonna Git You Sucka*.
He began moaning notes he didn't know

he'd known. Lyrics from his childhood
in church. The choirs he'd once believed
went on too long; preacher with the word
of the Lord down to a formula, even

knowing when to get upended via Spirit.
The fish stayed blinking his bottom lip

like a drawbridge, but instead of platelets
of skin, swam satisfied with his whimper.

Some teens spied the man in his failings
& called him crackbrained, but moving.
Soon passersby who frequented the ales
& overpriced restaurants that sell bougie

deviled eggs, & tourists of general stores
that boast "I dared" with "Pendleton
Since 1863" decalcomania began to pour
into the alley to hear the homeless siren

with dancing fish. Swaying really. Then
in came boosters & talent scouts bent on
profiting off anything that could bring
the old town glory. They came with lens

that cha-chinged each time they captured
the scene, notebooks looking to draft
a story that would bring fame, & tourists
that never asked the man's name nor if

he needed food or something to drink,
but gawked with folded arms or akimbo
like cheap trophies wearing *well I'll be
damned* faces. The fish overwhelmed

& charmed no longer, swam back into
the ribbon of oil from which it came,
& one by one onlookers cleared out.
The man scratched & wept & screamed,

& after seeing his only friend leave,
balled his mouth & inflated his chest.
The man scratched & wept & screamed
& whimpered until there was no head left.

THE LIGHTBULB ROOM

The best way to advertise may be to leave
the lights on: showcase the chandeliers
until the van/dals clear out — the watts
& what nots — the fixtures fizzing behind
the glass like a cathode's paunched picture.
Overhead is what hangs above, overhead
is who does the hanging, overhead is that
rid/iculous ass utility bill you keep paying.
 triple entendre don't even ask me how
I think Edison's edify Ellison better than
any other bulb. Its almost invisible skin
& fi/lament filling in where my reasoning
should've been — *but these bright lights*
turned me to a monster — please love me
with your whole lobotomy — screw my
head back on. I am drawn like our moth/er
to a store's facade. I can't afford anything.

COMPARTMENTALIZING @ THE REFINERY

You are here * In your apartment * Then you are here * Outside your studio when the communications director asks if you have a second * Asks what's your craft * Artist * Asks poet * Artist * But you write poetry right * You don't break down the word poiētēs * You don't tell the communications director you earned a degree in graphic communications & creative writing * You don't define pigeonholing as a small recess for nests * You don't define pigeonholing as a desk compartment in which letters are kept * You don't define pigeonholing * You don't explain the whiteness of the dove * If you had a feather * You say * For every time * You say * Someone didn't take the answer you gave them * You say * You'd only need strokes of tar * You say just put writer * The communications director says * OK * Clipboard strolls into the office that borders your studio * The wall soon to be knocked down * Renewal * You are moved into a cubical that communicates you are a writer * You are here

TULSA SEARCHES FOR SASS GRAVES

is the headline but when you click
your tongue a dog will come running from
behind the tombstone labeled *Dick*

but not the dick you're not thinking
or willing to bring you to a page where mum's
the headword though when you lick

your thumb there is no page to flick
over only the head of a bongo drum
behind the Tombstone labeled *double-decker*

which is huge when you realize just how much
cheese you can fit on a Ouija Board or rum
to the head but link up with your clique

& you'll see you have help in the deck
of Tarot that appears as soon as you slump
behind the hewn stone shaped like a dock

where there lies only goose shit & a duck
whose quack mirrors the cackle of a chum
in the headline you dared not to click
who isn't beneath the tombstone labeled *Dick*

ST. LOUIS I.M. & S. RY. CO. V. FREELAND

> *In 1913 it denied recovery to a white woman who was put off a*
> *train at the wrong station, then rode in an integrated caboose*
> *car to get to her destination. She wanted compensation for*
> *having to travel in the same car as Black men.*
> — Alfred L. Brophy

& where in the Outkast "Rosa Parks" did she sit?
In the front of the caboose clutching her purse
or in the back of the car pursing her lips?

& how awkward of an orgy it must've looked.
A lone, perhaps not single, white woman perched
around all of those strapping beautiful men. Black

men. 1913 Black. How they might've felt
she might've felt insulted, even a tad bit parched,
thinking that they all wanted her to jerk their belts

off, as opposed to the novel adapted into the film
Mandingo. As the story goes, a slaver's perverse
wife is left alone, but instead of taking to her heels

like George Washington's widow, she stays.
Well, not only stays, but straddles him like a pure-
bred steed. No, mounts him like a domesticated

dog. D—I—NGO—clap—clap—clapclapclap.
I imagine it was as uncomfortable for the porter
as it was for the white woman who got off

at the wrong station. A type of punishment
for a mistake they'd made, so that she pursued
compensation for having to ride with the men.

Black men. Beautiful Black men. I imagine
her exiting exhale & the exhale of the personified
train climaxing at the very same time. Her hoofing

it away in her flats, looking back every third stroke
like a swimmer turning their head in pursiness.
How humiliating, trapped inside a headlight's focus

of her traipse across the tracks, & the dark rails
glistening, lubricated by rain. A persecuted
shadow reaching to the Black side even as she lay

awake, ashamed. Her husband satisfied. The train
whistle of his snore. & her shoving two perceptive
fingers like a shovel where the coal feeds the flame.

PIONEER WOMAN, PONCA CITY

for Shanley

I, too, overlooked the forty-foot bronze statue
that looks over the museum lawn. The sunbonneted
Madonna herding her son across the new frontier,

Good Book, purse & all. My excuses: dusk
is a type of fog; I was focused on the roadkill;
I found the foliage in the background distracting;

none of the above. On entrance, the docent told me
men, day after day, do-si-do past the sculpture,
through the same cool doors to ask the same dopey

question of *where is the Pioneer Woman Statue?*
To which, straight-faced, she shows them the way
she motioned for me to about face & trace my

roots if I truly desired to see the puissant mother
with pissant child raised twenty-three feet from
the ground. Monument twelve male disciples fought

to erect. The mother cradling a Bible that odds-on
holds her absent spouse's lineage in her right hand,
& a boy who'll rise to repress his lovers in the other.

THE CREEK COUNCIL OAK TREE

for Joy

Much of Riverside's wildlife has been replaced
with statues in their likeness, but the oak remains.
I was led by a dry wind from a coffee shop
Google Maps still shows as under construction.

The wind replied *that's what she said* when I said
I thought it'd be bigger, having climbed the splendor
of live oaks in my native land each year I find
harder & harder to call *home*. She said, *as a child*

I roamed the sweeping branches in Congo Square
where your ancestors played for habitués who now journey
from sea to tarnished sea to see what they can hear.
The wind went on wailing about the clad iron

corralling the lone oak, but all I could think of
was how "The Blue Dog" in *Wendy & Me*
depicting Rodrigue beside his bride was stolen.
Or how the dog's spectral yellow eyes resembled

two freshly docked stumps from the skies.
Over her knee, the wind broke a fallen branch
to snap me out my trance. Said, *if a tree dies*
& falls into the arms of another then it is at the mercy

of the fungi which communicate & share underground.
I'd grown up miseducated, as I'd marched
down a street named for the very canal it covered
but could not sense its presence. As I'd thought

the Trail of Tears a season five tribes traversed
when it was over forty years & included freedmen

& slaves alike. I told the wind I'd recently driven
through Okmulgee & beheld a sign that read

Five Civilized Tribes Museum, but she didn't flinch.
I told her I felt transported to an earlier era,
that my word processor argued if *Okmulgee* exists,
so I had to learn my Mac out of its bloody errors

instead of waiting for the next snow to correct it.
Nothing. Not even a gust to the back of the knee.
Then, suddenly, she started on about Confederate
soldiers stealing whatever they could find. *Even*

the globe, she said. *They rolled their maps into telescopes*
& looked out until they felt they were onto something
bigger than themselves. Onto the trees, unbeknownst
to how they grow in when the branches get close to tangling.

If not the werewolf, I said, *then the gaunt ghost dog*
will haunt their descendants, but I could no longer feel
her presence, & the sun was setting like some god
tired of hearing the same confessions. A flurry

blew in, & I knew it was her pushing me along.
She galed, *to Green Corn*, where I looked on
at the Muskogee Creek stompdance. A ring of
woman-man-woman-man-woman-man-woman

I imagined might've looked like the vent
of a pie crust to a satellite. I shook off the bronze
casting, watched her turn from wind to woodwind
to woman, then lapped blueberries from her palm.

CINDER/ELLA

VENEICE SIMS (1904 - UNK)

I told the seamstress I wanted
my dress to flow like sheer curtains
when the windows are open.

Nothing caressing the floor
cause I wanted my boyfriend
to like it, but nothing too short

either, cause I wanted my daddy
(who didn't know I had a boyfriend)
to approve. Me & my girlfriends

were so excited. We'd waited
four feverish years hearing of prom-
ises traded & had finally made it.

I hated the way the corsage
cuffed my wrist, but loved the pearls
my seamstress kindly let me don.

They looked like the cord you pull
on the curtains to let the world in.
A choker nibbling my collarbone.

THE SOI DISANT

Jungle Boy scarfed the snake
around his neck
as if he needed to be kept
warm at Tulsa's 30th Annual
Juneteenth Celebration
held in a vacant flood plain
on a campus fitted for
20,000 scholars that fails to
exceed 5000, instead of north
squalor or Guthrie Green
where Black folks don't show
unless Doug E. Fresh
& Big Daddy Kane rock
the stage, the field adjacent
to the adjunct building erected
where Greenwood
thrived before assimilation
or the interstate's partition.
He donned the snake as
if to audition terror, to gauge
how far we'd come
from genetic trauma, told me
he'd been stapled a few times
but nothing fatal,
nothing to make him fetal
like a feral cat taking a nap.
He modeled it to take pictures,
said he charged five dollars
here, fifty in Miami,
Oklahoma, said
his family knew of his
infatuation since his youth,
that he sought his friends

in collars & collards, some
collage of his living animus
for education, for my friend
to take a free picture
of us & his four-foot python.
My heart flushed
with confusion & a fear
that comes from something
so foreign I couldn't pet
or put my finger on it, though
both photos with my arms
folded say: I was brave.

$465,000,000 GATHERING PLACE

The goal was to bring the vigilant together
with descendants of vigilantes to shatter
the world record for largest electric slide,
AKA, the bus stop. A feat of five-thousand

& one people that seemed feasible in a city
of four hundred & one thousand, respectively.
The Marcia Griffith, Reggae songstress renowned
for her hit "Electric Boogie," was in town,

& I wanted nothing more than to shake
a leg with the Kingston Queen. I'd seen teenagers
& elderberries alike bopping to the syncopated
rhythms of waiting. Listened to the accordion

bus & its hydraulic sighs also dipping
forward, back, then forward again, stepped
side to side making room for other commuters.
Griffith sung of "Dreamland" too, though its

tempo isn't the *boogie woogie woogies*
I came to know after weddings & funerals,
but more like a song of the promise land playing
from a topless Model T used as a nickel jitney.

Now, whenever I see a bus stop crowded with blue
collars, I imagine flash mobs sliding across lube
that stains the pavement. A dance sequence
passengers can learn en route to their destinations.

Many like me wanted nothing more than to shake
Griffith's hand & what our mama's gave us,
but by the time we trekked from our wilderness
there wasn't even a mule left to take us.

$36,000,000 RESTORATION
OF THE TULSA CLUB HOTEL

Back in the '20s when they built these buildings, they were
solid. So the bones were always good, and that's what made
this project viable. — Pete Patel, *Tulsa World*

 T h e y

found bats

 in the building

 They found water
but the floors intact

 T h e

homeless

 made it

 a
 t o r n
umbrella

 They burned it

 d o w n
without a match

 They rubbed their

hands together

 one winter &

 the

 w h o l e
world caught fire

FIRST SNOW @ THE REFINERY

You are here * Soundless * Asleep * After leaping through the street like snow bunnies * Fresh sheet you * Your closest friend frolicked through when the coastal was clear * Not a North American peep * Save truck deliveries * Back alleys * Backstreets * Boys * Back * One jeep passed * Wildebeest * In fur * You bounded past the theater with so many name changes its masks do not answer no matter what name you infer * Thalia * Melpomene * Facades you know from Mardi Gras * Crowds awaiting the parade * Marching three abreast out of clouds * Smoke machines * Truck * Horses draped in white robes * Even a burning cross * Article that didn't read * Night klan finally kame out of the kloset * But instead read * One could almost hear a pin drop among the mass thousands * Like last night when you * Your friend pranced through the arts district with a terror you couldn't name * Everything silent save your feet chomping the snow * Streetlights * Their fangs of ice * Sickles * Sickly * You are here

DOMESTIC DAY OFF: HANGOVER

What the chauffeur whistles is a tune
he's never heard before other than in his head
dead-set on last night in light
of the stars standing in for streetlights
& the only music playing from his good shoes
hoeing the dirt roads, his pocket watch
telling him it's time to go, staying
instead, knowing he'll catch a nod or two
waiting for boss, which he calls him,
them, because that's what brings the liquor
money & allows him to hustle back to
the streets where his lady bends
(like she's vacuuming the same stubborn spot)
almost enough to kiss his silk
-smooth face beneath the awning
of his driver cap he chucked when she drew
so near she could hear it too,
the charming ditty that in the morning
kept his lips the same way she left them.

<p style="text-align:center">❧</p>

What the housemaid hums has no drum,
no bass player to pizzicato with
the cheeks of his fingers, but something upbeat
that soothes when the break comes down.
She irons in creases thinking
of the only *darling* she'll answer to. Her sugar
who melts her into the gutters she slithers
without missing a step. She's not worried
about two left or who's left tending to the floors,
washroom, definitely not the flowers
in all their freckled glory stretched on both sides
of the walkway like a wedding party.

The petals are asleep. Necks bent chin to chest
like a man who's nodded off
reading the racist paper. Something about
"Nab Negro for Attacking Girl in Elevator."
Something more outrageous than dancing
to no music. A real silent disco. She pays
no mind to the white men sneaking into
the speakeasies from the other side of the tracks,
'cause ain't none of them paying her to mind.

DAPPER

for Chris

Looking at the moon was like looking
into a canister of Murray's Pomade,
the night I dodged bald spots down
a sketchy back road to the only Black
barbershop in town. I wasn't overdue
for a fade more than I was Black love,
& when I walked inside it was all love.
After the daps & head nods, I looked
around at the razor bumped walls due
for a paint job & posters of men made
into candid mannequins & felt Black
again; felt my shoulders come down
& sag over my folding chair. I'm down,
I told the gold grill I gathered loved
to play Madden. His name was Black,
his face tatted with sheen. He looked
at the screen, then back at me, made
a touchdown and shot to his feet. I do
need a cut, I thought, seeing the dew
settle into Fat Rob's face. He owned
the flat, but swaggered like he'd made
the building; like he'd pulled on gloves
& laid brick by brick. Barbers as kings
permit we sit their thrones. The black
tiles made it hard to see coils from lack
of light. There lurked an earthy residue
in the room. Something freethinking
as the spliff passed, the air drowned
out by the dozens we'd grown to love.
The wisecracks our ancestors made
for their own entertainment; the maids

& butlers cackling inside the all-Black
back of houses. A tilted form of love.
Once my brother paid what was due,
& oil sheen settled in the run-down
room, I glanced to see Fat Rob looking
my way. He wiped pomade on a black
rag, & nodded I was due to head down.
To be made good-looking, to be loved.

TULSA STAR

ANDREW J. SMITHERMAN (1883-1961)

Smitherman is what they see & think
Smithereens. Think, *thou shall be
Smote for thou front page inequities.*
Smitten rather, by their failed confederacy,
Smidgen of hope they call equality. I
Smirk, understanding they always wanted this land
Smirched. For what it's worth, I'd happily
Smear their crude, gainsay their gains again against
all odds, even if their god came back
Small & smart as the youngest of our brood.
S'mores are what the children ask for.
Some more stories! They want all the subdued
Smoke of our history. The buildings
Smoldering; the soldiers & doctors; painters'
Smocks the oldest don't see in their textbooks;
Similes likening records to poetry. But I just
Smile & say instead: *It looks like it's time to go to sleep.*

PESTICIDE IS TO CHIGGER,
AS TURPENTINE IS TO _____

As kids, he said, me & my brothers
waved flags at the edge of fields
to guide our father's crop duster.

We couldn't hear for the propellor,
& squinted whenever the pesticides
misted our surrender. Disgusting,

right? We were insane. We were
podunk, country bumpkins filled
with a pride white as rice, stubborn

as the brink of grain. Our mother
was bright enough to stay inside.
To cook what we raised, harvested,

& eventually herded for slaughter.
The toxins burned when they fell
on our skin, & burned when water

doused our spires. The worst part
was rinsing the fire from our hides.
Mine felt like it glowed in the dark.

INCEN/DIARY

considering the Upstairs Lounge Fire

We tipped our sticks to the gravel like the bent
spines of men groveling beneath trunks of smoke

to lure barbed larvae from the oak-sheltered path
horseshoeing the Catholic church.

The same church we'd slink inside to extinguish
our June-noon thirst, & same oaks buck moth

caterpillars fell as if the boughs were crowned
in flames. Never did they sting us.

Still, we considered it a service to the cul-de-sac:
cull as many locomotive pests as possible;

scrape them into an inescapable jar. Their heads
red as fresh scabs; as the 32ct matches

prior to us striking the tips against the celled strip
of friction. When the burning caught,

they jerked & swayed like lovers behind a piano
set ablaze, their guts gushed black as tar,

& their remnants wilted like the butts of old cigars.
We took a step back, & listened to the fire crackle

like leaves underfoot; beheld a few hump away
& others glow in ascension. We witnessed them

become charcoal-winged combustion that flitted
from white to yellow to orange to nothing.

WASHINGTON PARISH FREE FAIR

Franklinton, Louisiana

For some reason, this was our yearly trip
across Lake Ponchartrain. Our class's whiff
of livestock, alligator on a stick, sugar cane,
fried frog legs & fresh-squeezed lemonade.

& for some reason, I thought it a good idea
to volunteer for the hypnosis fodder.
To take the main stage with five others
in front of hundreds & hundreds of eyes

I didn't know, as some white guy in a cape
& tie showcased his power. He told us to sit
& we sat. He strolled by whispering
instructions & we all went along with it:

Ok. Whenever I say "bah rah gah doh"
& wave my wand make like you're sleeping.
Ok? & whenever I say "doh gah rah bah"
make like you're waking up from a long nap.

Even now I wonder if audience members
perched on foldout chairs or plunked under
scrawny trees could see me faking. Wonder
what would've happened had I stirred

before he told us to, instead of going along
with the ruse. What I would've done
had I known there were folks in the audience
who owned robes & hoods. Folks I'd stood

beside or passed chucking darts at balloons
& shooting moving targets. By sunset
the hoax was over, & it was time to get
back on the bus. My classmates swooned

& cheered & even the girl who never
liked me held my arm, happy I wasn't sawed
in two or transformed into a talking sow.
Even better, that I wasn't made to disappear.

HOT GIRL SUMMER

I'd grown up on Partners-N-Crime's "New Orleans Block Party,"
but it was unwinding under the hipped roof & awning
of my hippy friends & listening to their teen daughter & sidekick
that I got hipped to the unadulterated meaning of "Hot Girl Summer."
Megan Thee Stallion, Nicky Minaj & Ty Dollar $ign having
combined their parentally advised talents to compose an anthem
to young women around the world who looked to be hot but not stolen.
The music video, as you may well know it, is a pool party
of women thirst-twerking & tongue-poking on hot pink chaises.
Back in my day <snort> this video might've been subjected
to BET's "Uncut" segment, which may be one step away from porn.
Instead the two teens adorned in loose jeans & crop tops
told us of the older "hot guy" they'd spotted coming out of Walmart.
How they approached who they called a "fine, middle-aged gentleman,"
adding, "Hot Girl Summer" simply meant "you do what you want."
I'd grown up on Rebirth Brass Band's "Do Whatcha Wanna,"
but eyeing their lithe midriffs & navels that squinted when they giggled,
I couldn't help but wonder what were the limits to boldness.
All of this on a porch in a city Oklahomans refer to as "The City,"
or, "the crossroads," because of the web of interstates.
All of this while my hippy friends, about as old as my parents, nodded
attentive, listening to their only daughter & closest friend
who still engaged in sleepovers talk about pursuing men while their son
was off at college with students who knew every word & ad-lib.
Every ward of their paranoiac parents directing how not to get taken
advantage of. For a minute, lazing beneath strings of light
hard not to find enchanting, I thought of the scrutiny & security
of close-knit neighborhoods. More peers meaning less disappearing.
Then how a trafficker might believe more highways means
the better their chances. I thought of the woman I'd known in passing.
A student whose face I'd recognized in a picture pinned
to a cork board of the coffee shop I'd frequented in grad school.
New baristas, new students, same thumbtacks, same poster:

Missing Person
Darian Michelle Hudson

MISSING SINCE: October 24, 2017
LAST SEEN: Stillwater, Oklahoma
HEIGHT: 63.0 in SEX: Female
WEIGHT: 120.0 lbs EYES: Brown HAIR: Black
TATTOOS: Tattoo of a feather and 5 birds with the script Birds of a
 feather flock together on the back of her right shoulder
 (see NamUs Images).
Contact Stillwater Police Department at 405-742-8357 with information.
Case #: 2017-32662 NamUs MP #: 40719

I'd grown up on the Hot Boy$ & Big Timer$ "I Need a Hot Girl,"
& maybe the young woman who resembled my best friend
had too. Darian, who like my friend, went off to a small college
town where the tallest structures were the stadiums & student unions,
but was kidnapped. Where in the sultry summer, there were shades
cloaking the cool & the cruel. Swimming pools in apartment buildings
that cropped up like crop tops, coffee shops, cream rising to the top
of their lattes. Quick run on a summer night that felt like any other.
After a while, I'd been asked if I'd like some tea or something to eat.
My friends' southwest hospitality having been snatched up by
the heavy wind that, in another life, may have been a breeze. A wind
that always seems to make its way around any structure to find us
sitting on a porch in a city, a state, a country where the difference
between citizens is who gets searched & who gets searched for.
I hadn't grown up on Sugar Boys and His Cane Cutters' "Jock-A-Mo,"
but I nodded my head to their offer as if to a song that wanted out.
Their cat statuesque on a ledge. Their blind dog pawing around.

MY WHITE WOOER WHISTLES
"WHISTLE WHILE YOU TWURK"

candidly, randomly as a swallow's
chirp in a grocery store, the fraught wings
twittering to & fro trying to find
its way out, its way into the cultured
milk, the aisles owls ogle when blackness
swoops in, the slammed door a spanking,
the checkered tiles frigid as a river
bed that fetters the north to the south
all the while partitioning — the window
that separates cashier from customer,
the kinfolk who drew the line in the sand-
bar & told us to take up the cross, cross
the current, the former, a dare, *dar he*,
a steam whistle's flirting, egret ass-up.

THE STEPS TO NOWHERE

for Eyakem

are all that's left
on the summit of Sunset
Hill, which is safer than *sundown*.
The homes erected then torn down
to make tracts for a pact never actualized.

My new friend
lectures light, mentions
the miracles of revolutions
& overcast, tricks of the horizon.
He directs me to foreground the sky

& take note
of the piles of clothes
left behind; the tufts of grass
fisting the buckled paths; the baskets
led like burros much too broken to ride.

We knew to go
from notions of *nowhere*
to *now here* were not as simple
as claiming a lot left after demolition,
though we figured lying down & trying

to envision
a bedroom & kitchen;
instead of shattered slabs
& the aftermath of land grabs,
a mattress & gas stove to warm the night

would make
a difference in the stakes.
It didn't, & we just ended up
spending all our time in rusted pipes
rushing to devour the last scraps of light.

THE INTERPRETER

for Yatika

Snaked barbed wire, rusted awning, iron
beams, browning lawn, inborn takebacks,
unkempt concrete, dry-rotted pallets,
plywood, no-goods, shattered glass, stray cats:

all that's necessary for protecting
the abandoned warehouse from the likes of
spray paint that brands the bricks anyway.
We'd set our eyes on the wall of white blood

meant probably to hide another
other than SERVER, who appeared
to have rappelled from the roof, or hung
bat-wise, shaking cans into hysterics.

Get this: the word canvas comes from the French
canevas & from the Greek *cannabis*
meaning hemp, which is to say Mary Jane
was made for artists & activists,

as opposed to the bigots who published
"Get Out the Hemp" as a scare tactic.
We didn't want to erase such a rich,
complex history, but to fashion

a mural that could serve as a gateway
into the land my comrade's ancestors settled
both before & after the Trail of Tears,
& to make art that showcased the level

Greenwood reached before Greenwood was reached
by fire. We took the number from the sign
that read Empire, & set out to sketch
what would become our concerted design,

but when we finally called, the owner
said, I don't like tattoos, so why would I want
graffiti on my building? & hung up.
We knew that he knew his decrepit haunt

was already laced with graffiti,
& thought he probably had plans to sell
to developers eager to benefit
from Greenwood's imminent centennial.

Still, it was a blow. Not because of the inked
skin of my comrade, or what was due
to be torn down. But because the building
stood for old thinking, too stubborn to die.

NEW STREETS @ THE REFINERY

You are here * Watching a steersman steady a laying pram * Steady * Too slow * Steady * The paint bleeds * Steady * Sticky notes * Placeholders * Reflective beads are hard to come by * You read online * Only 1 in 1000 master the technique * Don't sweat these dividing lines * These minus signs * Finish the bike lanes * Toss cones * Teeth * Nutria orange * Candy corn * In a truck bed like the dead * You awaken * Draw shades * A grand reveal * Someone graffitied * no bikes * kayaks only * no bikes * kayaks only * no bikes * kayaks only * no bikes down both margins * As far as you can see outside your awning window * You think the spray paint looks like chalk * Black Lives Matter stripped from the district * You chuckle * A guffaw would startle the starling that perched on your sill * Flew in to greet you one morning * If it still came around * Disappeared with the others * Constructing obstructions * No dawn downtown * You are here

DIRTY BUTTER CREEK

What I would've given to be a 1929 fly on the Memphis
or Mississippi walls of Minnie Wallace's digs when she wailed
it's dirty butter, or in Paul Prudhomme's home when his

cast iron discovered smoke. If anyone asks if burning is failing
or if *blackening* was an accident say *hell no*. Say it's more
like making *born* smell *burnt*, or a backdoor creak like a cello.

Minnie Wallace's quiver sounded like her vocal cords
were scorched, like the river dried to a creek that dried into
a ditch. What's magic to one may be tragic to another.

Imagine the splendor of eating what you'd been taught not to
serve, then realizing it tasted better than what the waiters
or menu could offer. Try rubbing your hands together

over a hot pot of water, say *burl* instead of *boil*, & *furl*
as opposed to *foil*, & watch how much better your food tastes.
To a fly, we live in a cockeyed world. *I don't understand*

half of what she's singing, the comment beneath the faint
pic of the music clip read, just like some folks have a hard time
trying to figure out why anyone would want to sear something

till it darkened to a crisp. The song starts with a sobering image
of Memphis Minnie holding a guitar by its head, Kansas Joe by
his shoulder, & ends with a drunken woman on the infamous

Beale Street & an officer knocking on her door, steadying
a thick glass of whiskey. It's a tipsy melody that lingers like soot
or the smell of a panfried fillet once the sugars caramelize.

Red drum is a fairly accurate name for scales that rust
whenever held up to the sun, as if offering a violin to *Lucifer,*
Lucifer, but I can't wrap my head around why anyone would

name the brown butter we sauce it with meunìere: a word
that means *miller's wife* in French, but sounds like shit
in English. I'd expect any stagnant thing to eventually whiff

of a sewer easement, but all I could smell was the subtle hint
of any other creek foul play was found in. I want one of those
stock pots that are so large I'd need a paddle to stir it.

A boat that creaks up & down a creek wearing a hole
the size of a peppercorn, which is about the size of a house
fly, which is about the size of my pupils, dilated, hypnotized.

PARIS SOUL FOOD

HAL (CORNBREAD) SINGER (1919-2020)

Beef Stew, Neck Bones, Jungle Juice
Good to Me. I Thought About You,

Fancy Pants, Blue Stompin' Kansas City.
For All We Know, There is No Greater

Love, Dear One. Hey Jude, I'm Still
With You. Dubois. Lina. One for Willie.

Nancy with the Laughing Face. Malcom X,
Brother, I'm With You On the Trail

With a Song in My Heart. Singer Song.
Blues for Hal. Solitude? Hometown?

I Can't Get Started. You Don't Move
Me, Fa-Fa-Fa-Fa-Fa. I Can't Explain My Love

To You. You Don't Know What Love is.
I have no more trust in justice.

NINETY-NINE

years later, I'm lying
in bed with a woman I would've been

killed for, could still end
killed for. My temple pressed against the barrel

of her navel like a child's
head against a window

as their mother drives through the night.
The father left behind, stillborn

in a puddle of blood.
Ninety-nine is the right number

if you don't want to cross the redline.
Ninety-nine doesn't feel quite like a dollar.

It feels quieter
than a finger raised like a bludgeon

by Brooklyn Nine-Nine.
My big bruda says *one*

hunid instead of goodbye.
It looks like *humid* but sounds like *hunted.*

Ninety-nine
years ago Greenwood's power lines were snipped

like umbilicals. Unbelievable.
No, you hang up

side down. Let the fluids rush to
your 59Fifty. Eyes closed. Neck

 slack. I am listening
to a heartbeat inside a stomach.

 Instead of the single quote
of an embryo. The gel was slathered cold. I could

die in my sleep & never know what happened.
 I could die from the euphoria

of too many euphemisms.
 I got ninety-nine

 word problems, but not the one
my sister slangs at her girlfriends.

A term of endearment.
A turn on indictment.

 There's a child in Maryland
with Jay-Z's face on it, what I just finished reading.

 I kept feeding her dollars ...
This makes sense if you listen

to "Drug Dealers Anonymous."
 Pusha T's eponymous

 single. Parent.
My father used to tell us *I spit y'all out, ptooey ptooey.*

I never heard him use the epithet but I know
 he thought it.

Dick Rowland was never caught with a blond
 strand on his person. That which glistens

 in the light it is colored by.
Last night, the news read, *the protest turned*

 to riots.
I made an O to cool my grits & became a griot.

If I was a drug dealer, I'd buy a used car
with a sticker price that ends in '99 Certified

 Today's Special
 As Advertised

No one would suspect me of dealing
 cards. Tulsa was dealt a Joker

 on Juneteenth. A holiday since 1980.
You see where I'm going?

Tulsa's BOK Center can seat 19,999 people.
 Senator Kamala Harris said

 This isn't just a wink to white
supremacists, he's throwing them a welcome home party.

Beno Hall as in *Be No Nigger, Be No Jew, Be No*
Catholic, Be No Immigrant

could fit 3000 constituents.
You deserve three stacks word to Andre,

Jay-Z tells Beyoncé.
By then we'll be free-floating in space.

Bae told me
when I can't sleep to count down from 100,

but I count the "100 Miles and Runnin."
I start at 99 then climb my way down

until I'm close enough to jump
without hurting myself.

I am always hurting myself.
Let the police cruiser set aflame tell it.

All of Greenwood burned
but one block. When the white fuses fussed

Yonder is a nigger
church, why ain't they burning it? The reply: *it's in*

a white district.
The priest makes hospital visits.

Leaves my grandmother
a plastic rosary. She says *there ain't many of us*

when I tell her of O.W. Gurley.
Her maiden name. If rap was alive

at the time, I'd dub him O Dub.
Uncle O Dub.

Maybe Jay-Z should've called
it quits after the *Black Album*.

Maybe I should've stuck with
ninety-nine couplets or 100 lines

of cocaine rhymes.
I need someone to cosign my consignments.

I got ninety-nine unread messages.
The one from my other bruda read:

*I have not been able to think beyond death & how it could
reach me doing the most mundane thing as be on the street.*

My other other bruda says *white people need
to get the fuck out the way.*

One day in high school riding
shotgun with some white dudes, he found a rope,

you see where I'm going.
Go home the police say. But we've already gone

& grown deaf from Jakes. Sirens.
On Billboard's Top 100,

"99 Problems" peaked at 30.
The age my other other bruda hopes to reach.

My bedroom fades to black & bae is falling
through the last

 hundred feet
or so to her rousing. If she could hover above

 the bed. If moles
were the jewels of the body, there would be more

 mining. I don't know how
to keep from crying. Why start what the world will finish?

ON YOUR FINAL NIGHT IN T-TOWN

for Laurie

Weren't they hitting switches & sitting
sideways, the men dripping in candy paint
on parade through the bougie arts district,

an exhibit never seen in our stints
in Magic City, their stunts of dragging
sparks from their blocks, lowriders tilting

on triplets rounding the corners, woodgrain
interiors, speakers seizured, drowning
out Main & Brady, & us out wagging

our arms at the dogs walking their owners,
the clubs distilled with nonsense, bike bars
peddling pop & hops, genre & green,

scene we barely believed, your car packed
so tight you couldn't peer out your rearview.

A NOBLE PARTING GIFT: ROSE ROCK

for my fellow Tulsa Artist Fellows

Because a rose can't wilt if it's a rock.
Because a rock will shatter when tossed across
pavement if it's glass, a skipping

competition was a must. Folks from all around
Oklahoma crowded the coast like a bottom
row of shark teeth. One judge noted

the rocks looked like an anus, another, a wad
of meat or shit you would have
to waddle like a goose or shake your fry-locked

ass to get out. Get, go on now, get.
The splash of the commode the same
as the splash when the stone is not thrown

at the right angle or is chucked
with too much force. "Tour de France
ain't got nothing on this," I heard a spectator

roar from his webbed lawn chair
where some vagrants had made the river side
of the levee their homes. The skippers

lined the banks where the Arkansas
& Verdigris hold hands while the audience
tried to avoid spells of vertigo

watching the confluence from a Muscogee
promontory. The preliminaries took place
in a pond locals & Mother Road motorists used

to swim. Rumor has it, it's now inhabited
by snakes & gators that swam up
from the swamps & marshes of Southeast

Louisiana & a whale that will live
as long as the district chips in for chalk-
blue paint every few years. Come October,

the championship will be underway.
Since the world record for skips is my born year
I signed up. One of the contestants

had one really muscular arm & heroin
veins that resembled the feet of a heron
or a great egret. Another contestant was a lawyer

running for state senate: pro-gerplunking,
pro-life & pro-gun. An uber-conservative
& Uber stock holder who specialized

in mediation & meditation. I never met
the dude who threw his arm out
on the first round. Or the guy who wore

hip waders. He walked out toward the lock
& almost drowned. Rescuers said it was like
pulling two men into the boat at the same time.

They gave him mouth to mouth
of the river, pressed on his chest until he spurted
water like a geyser of black gold.

My best friend, who talked me into this,
& is also the same age as my father, is a natural.
He wears neither deodorant nor pants

& no one tells him a goddamn thing. He sings
to himself. They nicknamed him The Current.
He croons to the debris & doesn't stretch

like me. He makes the whole shebang look easy.
I think the secret lies in his calves
or the calfs he roped as a boy. I think

he has the most stunning legs of any participant.
His hair coils like wisps of monofilament
or a not-fully-formed maelstrom.

One afternoon, he skipped a rose rock so far
it made it to the other side. I know this
because when we walked on water

to the other side there it was, right beside
all the other rose rocks. Some had hearts
& initials scratched into their backs.

Some had petals weathered before
they were beached. When the moon tries
to spoon the tide, they may get carried downstream.

Since the world record for longest skip
was hurled on my 30th birthday,
the smooth stones I skimmed were all woman-made.

A wiseman once said "We must be
like the rose rock: let the wind wash
over us, and the water iron our edges."

The expensive & expansive paperweight I skipped,
as in pelted the surface with, may get carried down
the Mississippi to the banks of my hometown

outsiders mispronounce. I'll know it's mine
if when I hold it up to the sun it kaleidoscopes
to show the facets of dazzling nonsense I left behind.

NOTES

"Genius Annotations Provided: "You Dropped a Bomb on Me" was written after the GAP Band's song of the same title. The trio, originally from Tulsa, fashioned their band name from three main streets of Tulsa's Greenwood District: Greenwood, Archer and Pine. The form is a PechaKucha, a Japanese presentation format adapted by Terrance Hayes.

"The Civil Rights Museum Desecrates the Memory of Dr. King" is borrowed from a banner of Jacqueline Smith. *Polishing a dream* is borrowed from Major Jackson's "Some Kind of Crazy."

"When Tulsa Nearly Killed Queen" is after Hugh Pearson's *When Harlem Nearly Killed King.*

"A Baby Wedged Between Two Buildings" is after the painting of the same title by Philip Frank.

The line "We are wrong. The wood reaches out/to the flame" in "Reflections on Reflections of El Lassitzky" is borrowed from Jack Gilbert's poem "Harm and Boon in the Meetings."

The line "Your arms too short to box with god" is from Nasir's "You're the Man," *Stillmatic.*

"To: Aboard, From: Abroad" is after Theater North's production of August Wilson's *Seven Guitars.*

Italicized lines in "The Jazz Hall of Fame" are from Yusef Komunyakaa, and Amiri Baraka.

"Suga Water" is borrowed from Arshay Cooper's memoir of the same title.

"I'm Gonna Get You Sucka" in "Panhandlers" is a callback to Keenan Ivory Wayan's 1988 film.

The title for the poem "Lightbulb Room" is borrowed from Ralph Ellison's "The Invisible Man." Both italicized lines are courtesy of Jay-Z on Drake's song "Light Up."

The line "One could almost hear a pin drop among the mass thousands" in "First Snow @ The Refinery" is borrowed from *Riot and Remembrance* by James S. Hirsch.

In "Domestic Day Off: Hangover," the line "Nab Negro for Attacking Girl in Elevator," is borrowed from the *Tulsa Tribune* in which Dick Roland was said to have assaulted Sarah Page.

The Upstairs Lounge in "Incen/diary" was a gay bar in New Orleans. After the lounge was set aflame and 32 people killed, the arson was hardly publicized, and churches refused to hold funeral services for the victims. It was the deadliest attack on queer people prior to the Pulse Nightclub Shooting.

The line "Get Out The Hemp" in "The Interpreter" is borrowed from the *Tulsa Daily World's* editorial against the Industrial Workers of the World (IWW).

In "My White Wooer Whistles 'Whistle While You Twurk'" "Dar he" references Emmett Till's great uncle, Moses Wright, pointing out Till's murderer during the court case.

In "Hot Girl Summer" the "<snort>" is borrowed from Robin Coste Lewis's poem "Pleasure and Understanding."

"Paris Soul Food" is a cento and also the title of Hal Singer's 1969 album. All lines are made up of Singer songs with the exception of the last, which is a quote from one of his last interviews.

BIBLIOGRAPHY

Adair, L., Keating, F., Savage, S., Taylor, S. *Tulsa Race Riot: A Report by the Oklahoma Commission to Study the Tulsa Race Riot of 1921.* 2001. https://www.okhistory.org/research/forms/freport.pdf.

Backes, M. M. *The 'Jungle Boy' of Tulsa.* https://www.tulsapeople.com/the-jungle-boy-of-tulsa/article_21913a66-bdd6-53fb-b391-0396461db855.html.

Bates, M. "Steps to Nowhere" https://thislandpress.com/2014/06/18/steps-to-nowhere/. Originally published in *This Land,* Vol. 5, Issue 10, May 15, 2014.

Brophy, A. L., & Kennedy, R. *Reconstructing the Dreamland: The Tulsa Riot of 1921: Race, Reparations, and Reconciliation.* New York: Oxford University Press, 2003.

Ellsworth, S. *Death in a Promised Land: The Tulsa Race Riot of 1921.* Baton Rouge, LA: Louisiana State University Press, 2001.

Geary, S. P. "The Night Tulsa Burned" [television series episode]. *History's Mysteries.* A&E Television Network. February 1999.

Gerkin, S. "Beno Hall: Tulsa's Den of Terror." *This Land,* https://thislandpress.com/2011/09/03/beno-hall-tulsas-den-of-terror/. September, 3, 2011

Gerkin, S. "Diamond in the Rough." *This Land.* https://thislandpress.com/2013/05/08/diamond-in-the-rough/. May 8, 2013.

Grann, D. *Killers of the Flower Moon: The Osage Murders and the Birth of the FBI.* London, UK: Simon & Schuster, 2018.

Hirsch, J. S. *Riot and Remembrance: The Tulsa Race War and Its Legacy.* Boston, MA: Houghton Mifflin Company, 2014.

Jensen, J., & Lendelof, D. "A God Walks into Abar" *Watchmen.* HBO Television Series. December 8, 2019.

Johnson, H. B. *Black Wall Street: From riot to renaissance in Tulsa's historic Greenwood District*. Fort Worth, TX: Eakin Press, 2013.

Jones, P. M. *Race Riot 1921: Events of the Tulsa Disaster*. Tulsa, OK: Out on a Limb Publishing, 1998.

Kirst, S. "In Buffalo, a Hero Journalist Found New Life After Tulsa Massacre." https://buffalonews.com/news/local/in-buffalo-a-hero-journalist-found-new-life-after-tulsa-massacre/article_a9d2b6cb-0188-50d7-b2ef-04245e04a9df.html. June 18, 2020.

Latham, J. *Dreamland Burning*. New York: Little, Brown & Company, 2018.

Matthews, R. "How Do They Paint White Lines on Roads So Accurately?" *Science Focus*. https://www.sciencefocus.com/science/how-do-they-paint-white-lines-on-roads-so-accurately/.

Wilkerson, M. (Director). *The Tulsa Lynching of 1921: A Hidden Story* [Video file]. https://www.youtube.com/watch?v=Iankhf7oXoQ&list=PLAZHQjiXQkWC3zdov-DJ95cEqKwswpsV1&index=48. 2000.

Wills, S. *Black Fortunes: The Story of the First Six African Americans Who Escaped Slavery and Became Millionaires*. New York: Harper Collins. (2019).

Wohlleben, P., & Billinghurst, J. *The Hidden Life of Trees: The Illustrated Edition*. Carlton VIC, Australia: Black. (2018).

ABOUT THE AUTHOR

CLEMONCE HEARD is the winner of the 2020 Anhinga-Robert Dana Prize for Poetry selected by Major Jackson. His collection, *Tragic City*, investigates the events of the 1921 Tulsa Race Massacre. Heard was a recipient of a 2018-2019 Tulsa Artist Fellowship and was the 2019-2020 Ronald Wallace Poetry Fellow at the University of Wisconsin-Madison. He earned a BFA in graphic communications from Northwestern State University, and an MFA in creative writing from Oklahoma State University. Heard's work has appeared or is forthcoming from *Obsidian*, *The Missouri Review*, *Cimarron Review*, *Iron Horse*, *World Literature Today*, *Poetry*, *Rattle*, *Ruminate*, and elsewhere.

Photograph by Heyd Fontenot